THE ANSEL ADAMS
WILDERNESS

THE ANSEL ADAMS WILDERNESS

PHOTOGRAPHS BY PETER ESSICK

NATIONAL GEOGRAPHIC
Washington, D.C.

THE WILDERNESS SOCIETY

DEDICATION

To all those who defend and find solace in wild places—the towering mountains,
the deep woods, the sparkling waters, and the essence of all life—and to the memory of my father,
John Essick, who first introduced me to the beauty of the High Sierra.

CONTENTS

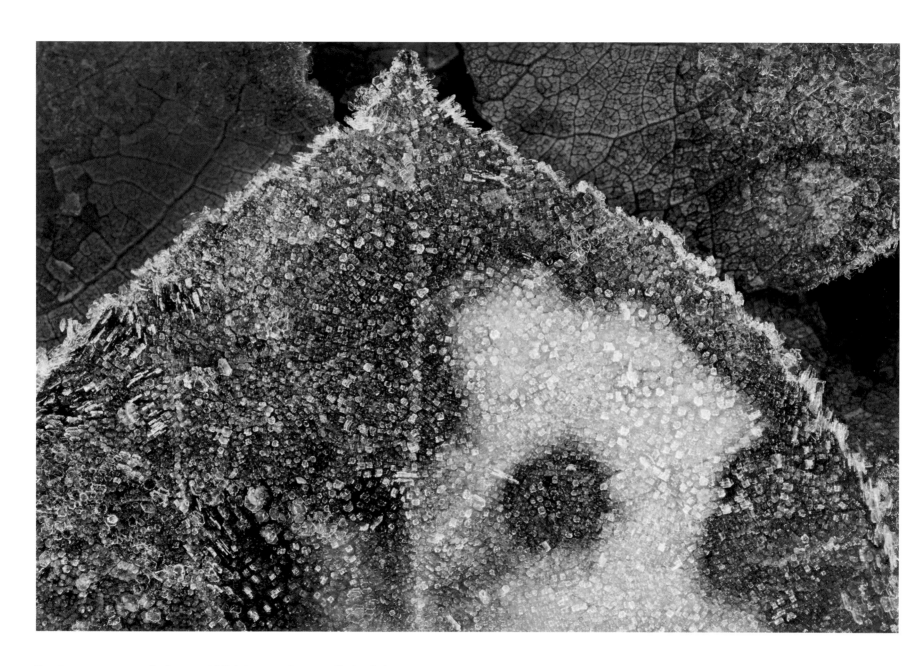

Frost covers an aspen leaf on a cold October morning near Parker Lake.

THE WILD AMERICAN SPIRIT

In 1916, Ansel Adams (1902–1984) visited Yosemite National Park and was transfixed by the beauty of the wild Sierra Nevada. The experience changed him—and the world—forever.

Ansel Adams devoted his life to photographing wild places, to producing iconic images that convey not only nature itself but also the deeply personal connection we feel to it. This kinship with nature has long been a wellspring of the American spirit, deeply felt not only by our greatest artists and poets but also by scholars and leaders. From Walt Whitman and Aldo Leopold to Theodore Roosevelt and Rachel Carson, Americans have always drawn strength and inspiration from America's wilderness.

But Adams feared for these wild places and warned that the "wilderness is rapidly becoming one of those aspects of the American dream which is more of the past than of the present." He served on the governing council of the Wilderness Society, joining our fight to save California and Alaska's coastal wildlands.

The landmark Wilderness Act of 1964, which marks its 50th anniversary in 2014, was the realization of a dream for Adams and other conservationists. As a result, we now have 110 million acres of protected wilderness in the United States. Upon Adams's death in 1984, Congress paid him the ultimate tribute by expanding the Minarets Wilderness in the Sierra Nevada and renaming it the Ansel Adams Wilderness.

That Peter Essick wishes to revisit the Ansel Adams Wilderness—75 years after Adams's photographs made it famous—is a testament to Adams's enduring legacy and a tribute to the Wilderness Act. As we reflect on past achievements, we must seize the chance to continue protecting endangered wilderness areas for future generations.

~JAMIE WILLIAMS
President, The Wilderness Society

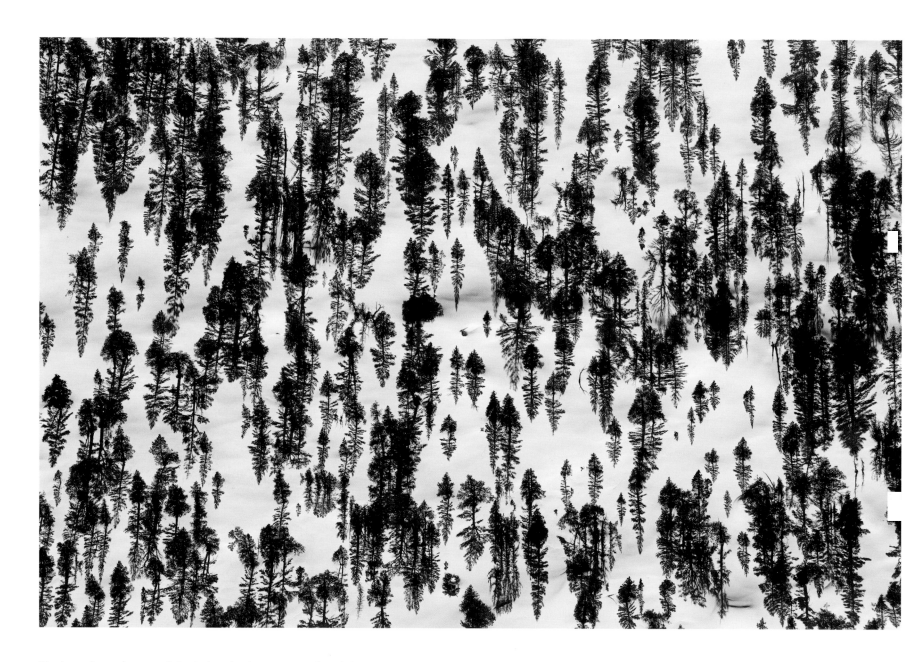

Shadows from afternoon light darken fresh snow near Gem Lake.

WONDERS FOR GENERATIONS TO COME

Recently, I discovered Ansel Adams's book *Sierra Nevada: The John Muir Trail,* which showcases the stunning wilderness of California's Sierra Nevada. This breathtaking landscape is home to the famous Minarets, whose sharp, jagged peaks have attracted daring climbers for more than a century. Adams's photos immediately struck me as simple yet elegant compositions; his straightforward black-and-white approach perfectly complements the purity of the mountains. These images left an indelible impression on me.

Like Adams, I am a native Californian familiar with the High Sierra, and some of my first successful photos were of this wilderness area (located between Yosemite National Park and Mammoth Lakes, and renamed for Adams following his death in 1984). For 25 years I have traveled throughout the world as a photographer for *National Geographic* magazine, but the High Sierra always has had a special place in my heart. So in 2010, after studying the book further, I submitted a magazine story proposal about the Ansel Adams Wilderness. I couldn't imagine a more fascinating project than taking black-and-white photographs of Adams's sacred territory—sacred in part because of his art that immortalized it.

I knew such a project would be stepping into a potentially controversial arena. Many critics and fans would say a landscape photographer would have to be either egotistical or foolish to shoot a story in the Ansel Adams territory and tradition. After all, not only is Adams our most cherished American photographer, but he's also recognized as the master of the form, with the High Sierra representing the hallowed ground of his art. Any attempt to follow in his footsteps with creative work of my own could easily be viewed as derivative.

Nevertheless, pulled by an irresistible desire, I carried out my initial research, which included talking to people who knew Adams, from admirers to hero worshippers to detractors who felt he was a symbol of bygone times. These encounters only intensified my inspiration to do the story and my passion for Adams's art.

For my *National Geographic* story, I wanted to pay homage to the master but not duplicate his work. It didn't make sense to go out and photograph the same places in the same style as Adams, 75 years later. Nevertheless, I realized I had been influenced by Adams's work and I wanted to celebrate that. In my mind, I came up with the idea of referencing. How referencing eventually translated into photographs went something like this: When I took my photograph of the moonset at Donahue Pass, I was aware of Adams's masterpiece, *High Country Crags and Moon, Sunrise, Kings Canyon National Park, California.* Our photographs share similarities—both were taken of a granite landscape in the Sierra Nevada above the tree line, and both feature triangular shapes. My intent was for the photograph to be my interpretation of the landscape at a certain moment in time, while also acknowledging the work that came before.

Most of Adams's best work was done during the period of modernism. Along with Edward Weston (1886–1958) and Imogen Cunningham (1883–1976), Adams was one of the strongest proponents of "straight" photography. This was not only photography's answer to pictorialism—which was viewed as a bad imitation of painting—but also was an embrace of the larger world of modernism. Many of Adams's photographs of nature during this time are beautiful compositions that elevate form by reducing a scene to its elemental components. Adams called this

method *extracts,* a way to turn landscape photography into an avenue for personal expression.

Throughout my career, my photographs have embodied meaning related to the time and effort that went into their making. This new landscape series holds even deeper significance for me, as the images connect intrinsically to my memories of being alone with my camera in a place as rare and spectacular as the Ansel Adams Wilderness. They also are reminders of what an inspiring presence Ansel Adams has been for me and so many other photographers. The universe can speak clearly in its pure and natural state, conveying both the spirit of the past and the wonderment of the new. I ask myself: What could be better than that? What could be better than to take black-and-white photographs in the Ansel Adams Wilderness?

~PETER ESSICK, January 2014

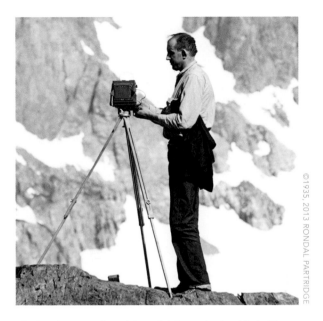

Early photographs of Ansel Adams in the High Sierra are rare. In 1938 his young assistant Ron Partridge took this picture at what is believed to be Volcanic Ridge in the Sierra Nevada. It was during the period when Adams was making photographs for his book *Sierra Nevada: The John Muir Trail.* Partridge later described the day as "stormy with electricity in the air." After taking this photograph, Adams and Partridge scrambled down the incline a bit, only to witness lightning strike the very spot where the photo had been taken. Adams's Sierra Nevada book was commissioned by Walter Starr in memory of his son, Walter Starr, Jr., an experienced climber who fell to his death on Michael Minaret in 1933.

Nestled between Yosemite National Park to the west and the John Muir Wilderness to the south and east, the Ansel Adams Wilderness can still hold its own in regard to spectacular scenery. In this rugged high country, granite peaks, craggy spires, alpine meadows, clear lakes and streams, majestic pines, and many species of wildflowers combine to form a sublime landscape that is the centerpiece of the wilderness. Most backpackers hike toward the large lakes beneath Mount Ritter (13,157 feet) and Mount Banner (12,945 feet), and the 17 spires of the Minarets in the watershed of the San Joaquin River's Middle Fork. However, the 231,533-acre wilderness also includes the Rush Creek Basin to the north, the remote North Fork of the San Joaquin watershed to the east, and the lower elevation, forested areas to the south. The Minaret Wilderness was designated as one of the original wilderness areas after the passage of the Wilderness Act in 1964 and was expanded and renamed in honor of Ansel Adams after his death in 1984.

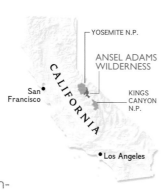

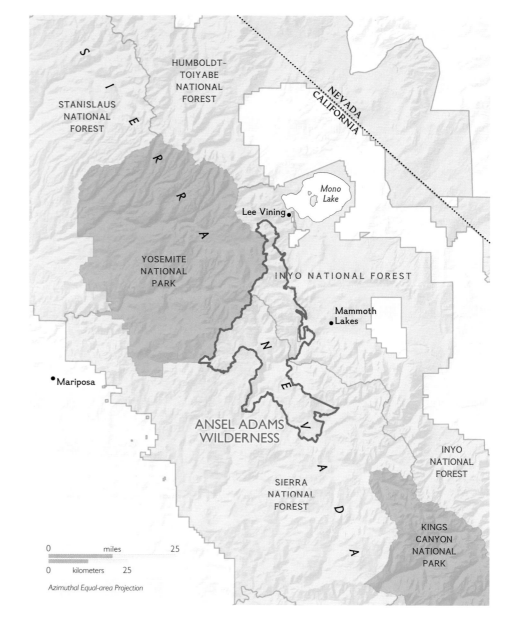

ANSEL ADAMS WILDERNESS

Mono Lake

Lee Vining

Dana Lake

INYO

Parker Lake

YOSEMITE

NATIONAL

Donohue Pass

Gem Lake

Marie Lakes

Mt. Lyell

Rush Cr.

Clark Lakes
Summit L.

San Joaquin
Mountain

NATIONAL

Rodgers Peak

Thousand Island Lake

L. Catherine

Garnet L.

Shadow L.

Banner Peak

Shadow Cr.

FOREST

Mount Ansel Adams

Blue Lake

Iceberg L.

Cabin L.

Cecile L.

DEVILS POSTPILE NATIONAL MONUMENT

Mammoth Lakes

PARK

Minarets

Nancy Pass

Superior Lake

San Joaquin

East Fork

West Fork

North Fork San Joaquin

Rainbow Falls

Middle Fork

SIERRA

Granite Creek

NATIONAL

San Joaquin

South Fork San Joaquin

FOREST

Creek

Lake Thomas A. Edison

Mammoth Pool Reservoir

Mono

Legend

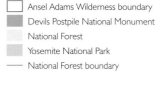

Ansel Adams Wilderness boundary

Devils Postpile National Monument

National Forest

Yosemite National Park

National Forest boundary

0 miles 10

0 kilometers 10

Azimuthal Equal-area Projection

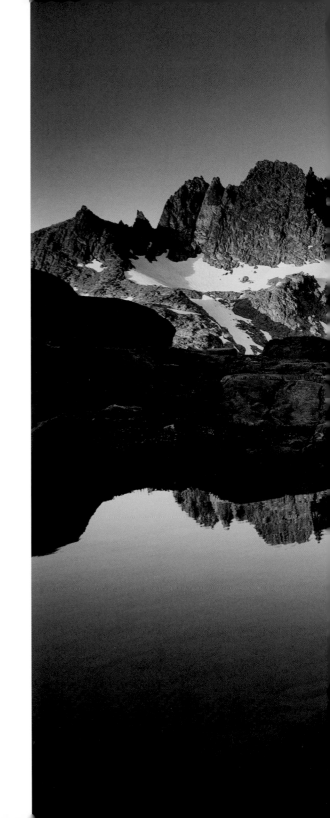

PEAKS
and
LAKES

At sunrise the Minarets reflect in a small pond near Cecile Lake.

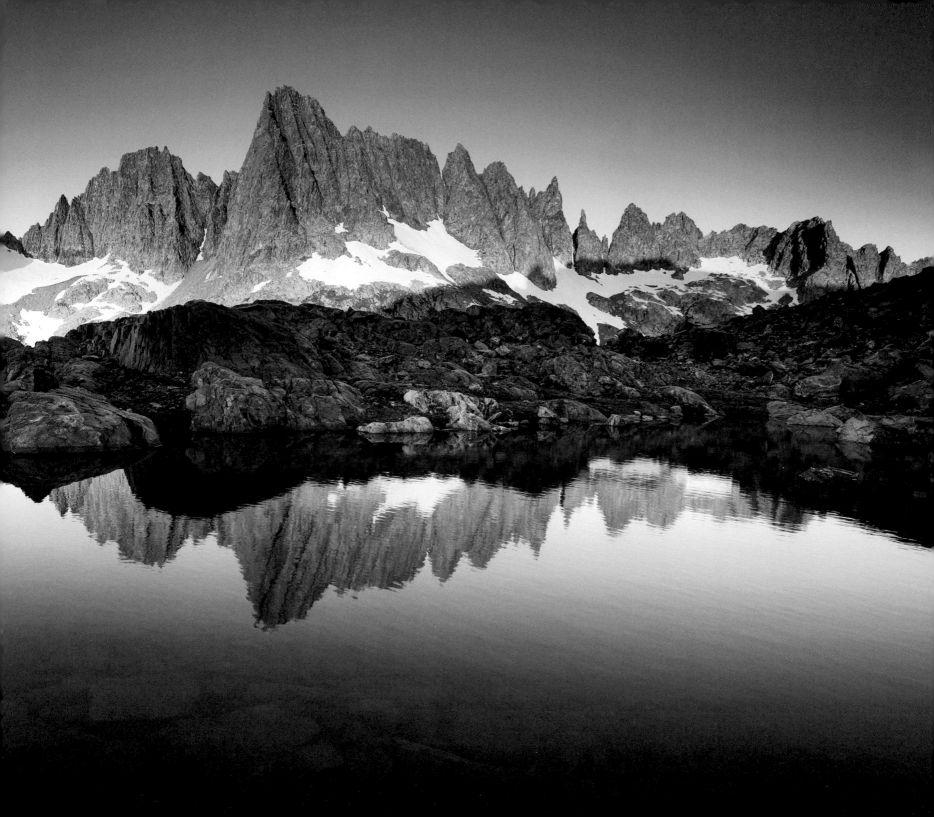

On the first night of many hikes into the Ansel Adams Wilderness, I made camp at the Clark Lakes. Soon after I arrived, I took the trail up to Summit Lake, where it was possible to see Banner Peak to the west. Near me stood a large, dead pine tree that would make the perfect foreground element for a photograph. I remembered a saying of Ansel Adams about how dead trees were more expressive than live ones. I looked at my GPS and noted that it was eight days past full moon, so a quarter moon would be rising in the middle of the night. This meant that in the wee hours of the night, it might be possible to take a photograph of the tree and Banner Peak by moonlight. I hiked back to camp, had a nice meal, and set my alarm.

When I returned to the spot at midnight, it lay in total darkness. Eventually, the moon cleared the mountains to the east and lit up Banner Peak. It was still rather dim out, but with an exposure of 30 seconds on the sensor of my digital camera I could see the mountains and a silhouette of the pine tree. The moon's opacity allowed me to see the Milky Way filling up the sky. I couldn't help but wonder what Ansel Adams would have thought of this scene. I'm sure he would have loved the sparkling Milky Way in the dark skies over a wilderness named for him. I'm sure he would have loved knowing that the sheer splendor of this place would always be enjoyed by generations to come—particularly with his dimension added to it.

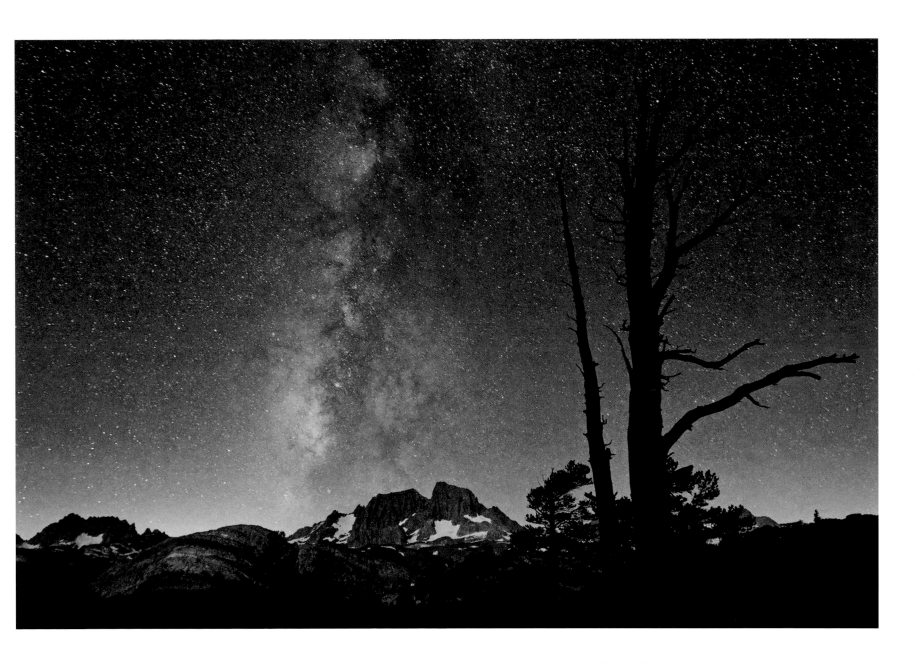

The Milky Way and Banner Peak shine in the moonlight from Summit Lake.

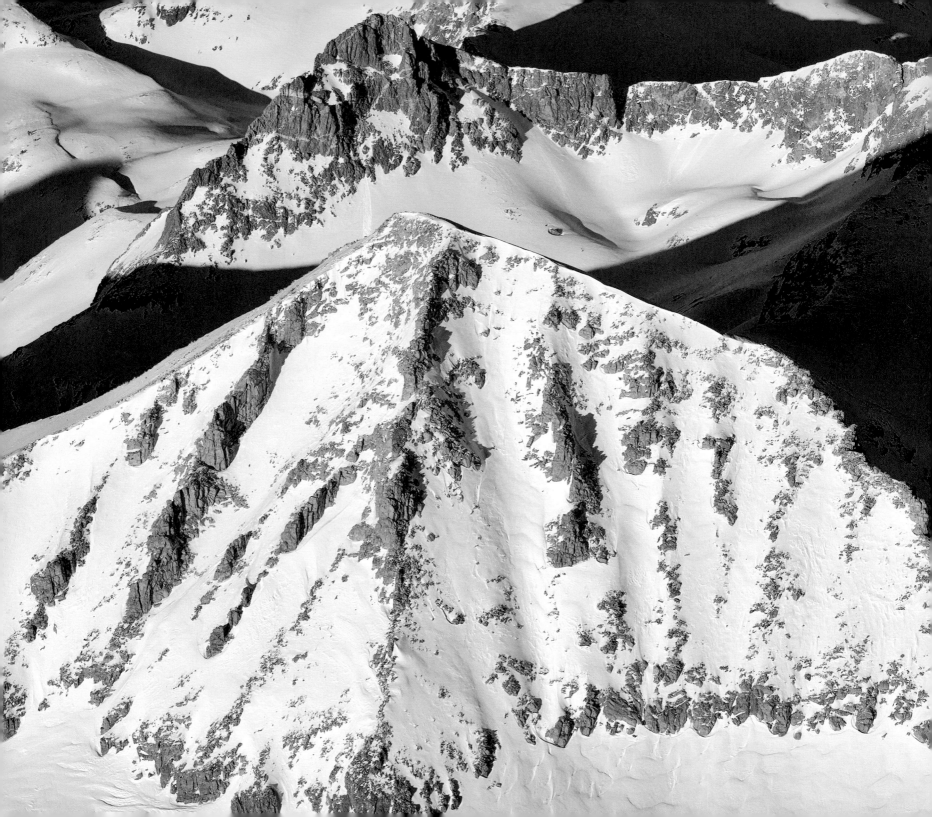

Sunset illuminates Mount Ansel Adams in the winter.

Climb the mountains and get their good tidings.
Nature's peace will flow into you as sunshine flows into trees.
The winds will blow their own freshness
into you, and the storms their energy, while cares will
drop off like autumn leaves.

~JOHN MUIR

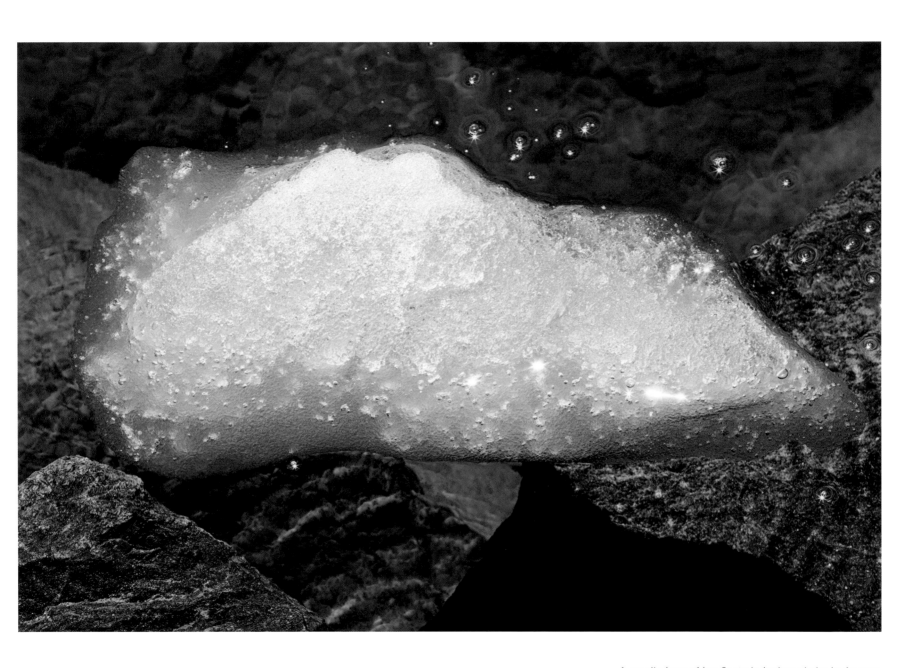

A small piece of ice floats in Iceberg Lake in August.

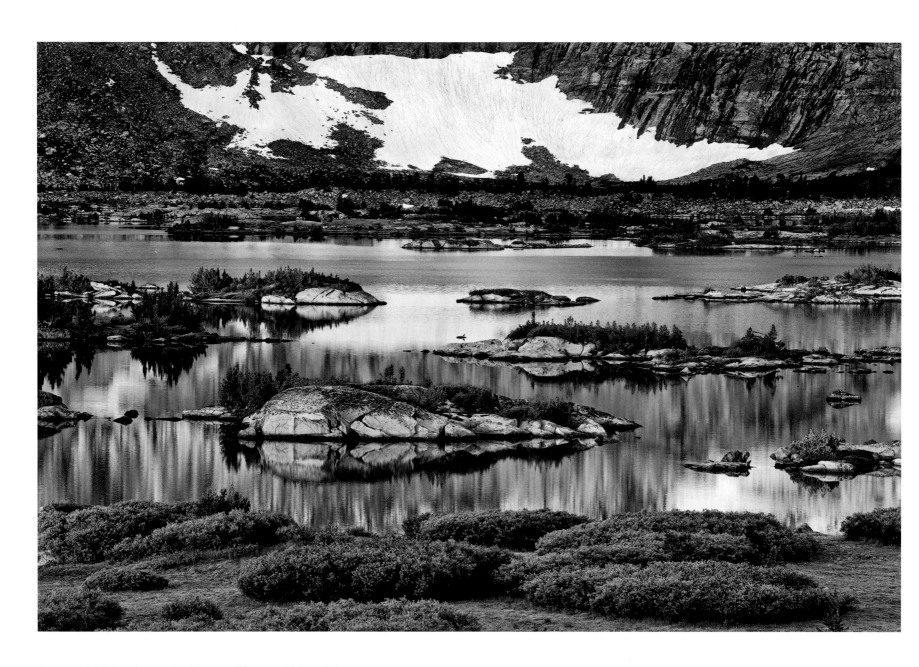

Sunrise highlights the granite islands of Thousand Island Lake.

Over all, rocks, wood, and water, brooded
the spirit of repose, and the silent energy of nature
stirred the soul to its innermost depths.

~THOMAS COLE

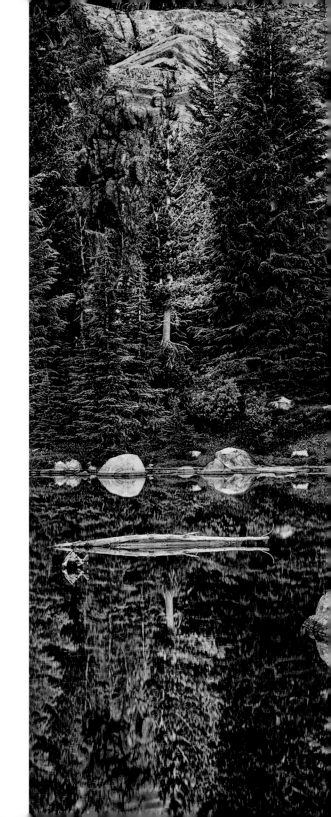

Reflections break the dawn's stillness on a corner of Cabin Lake.

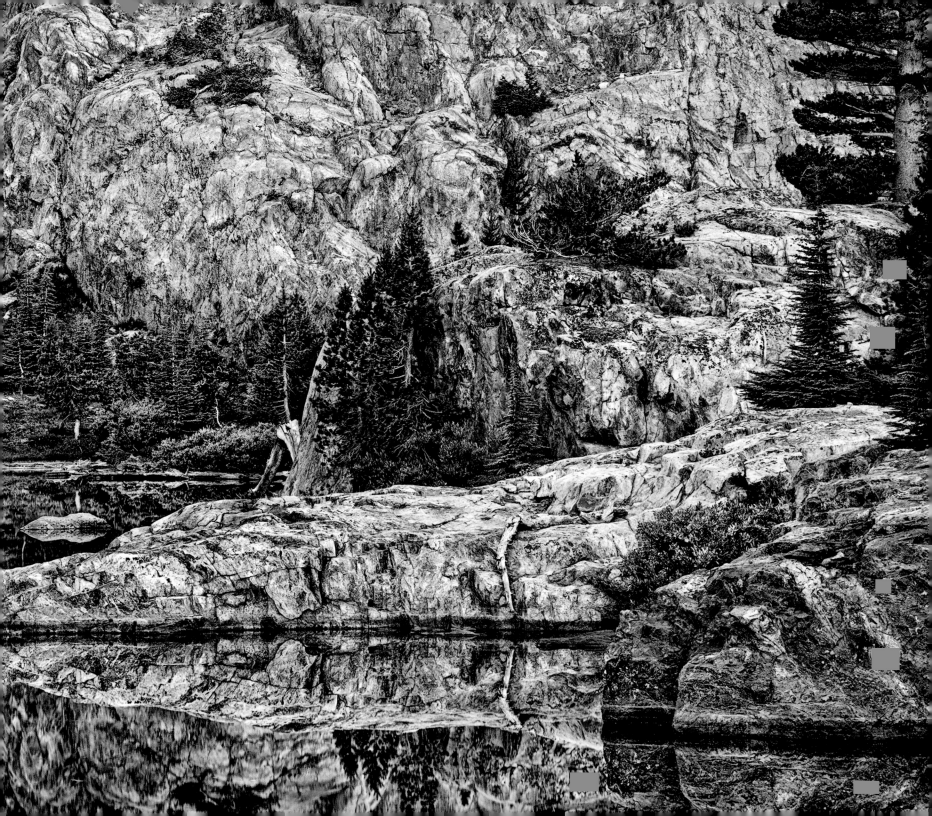

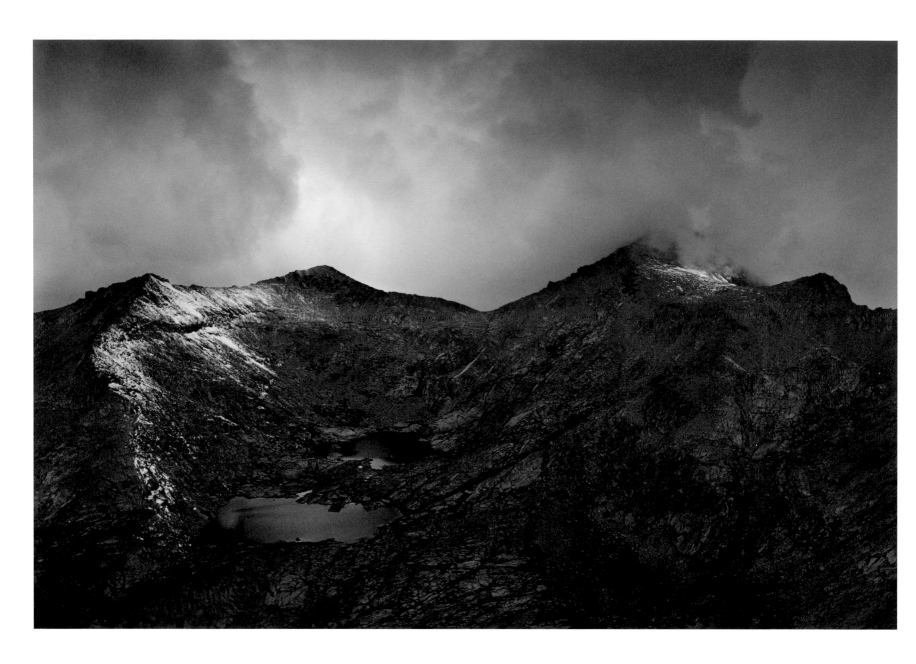

Clouds form on a ridge behind Blue Lake at sunset.

Nature is a mutable cloud which
is always and never the same.

~RALPH WALDO EMERSON

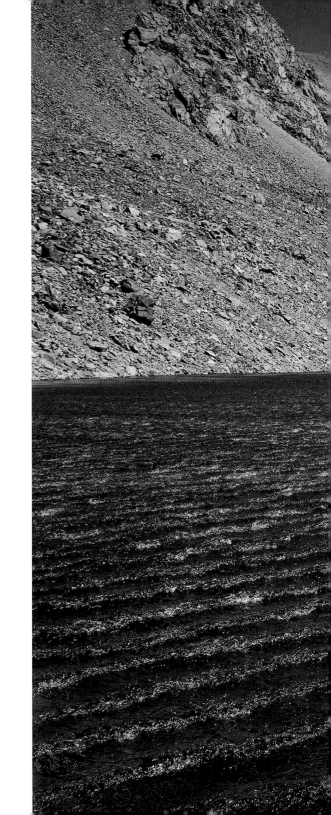

A strong summer wind makes whitecaps on Dana Lake.

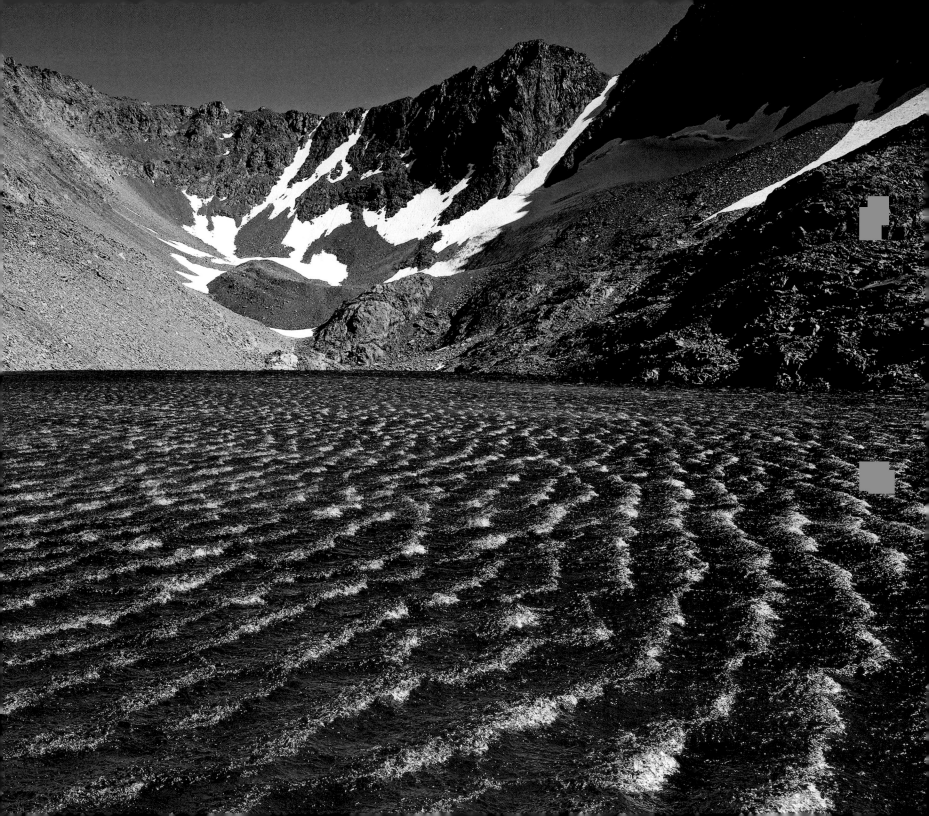

Mountains are earth's undecaying monuments.

~NATHANIEL HAWTHORNE

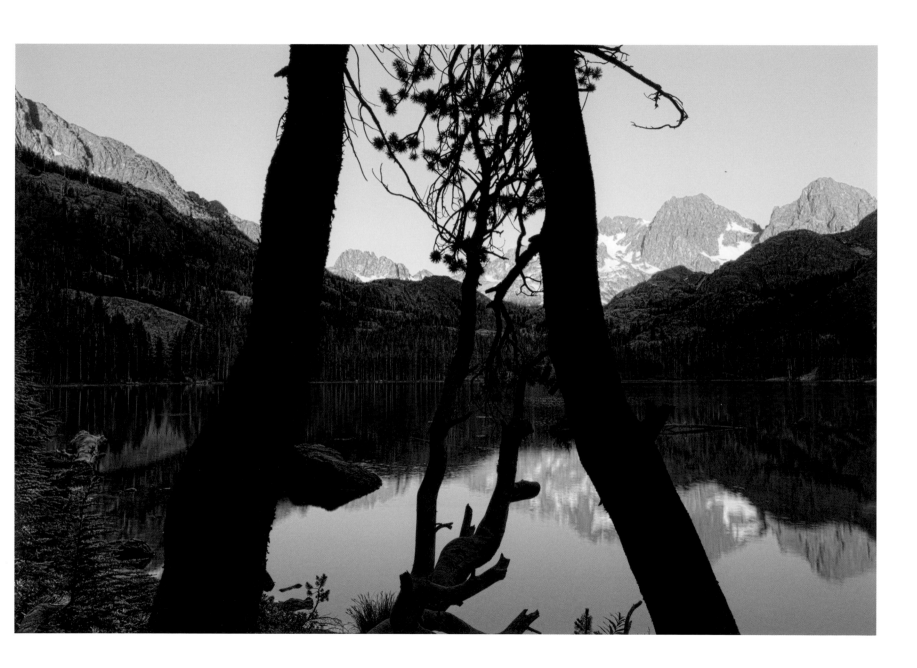

Shadow Lake remains shrouded as the morning sun hits the mountains beyond.

PASSES
and
MEADOWS

Photographed from Nancy Pass, afternoon clouds form behind the Minarets.

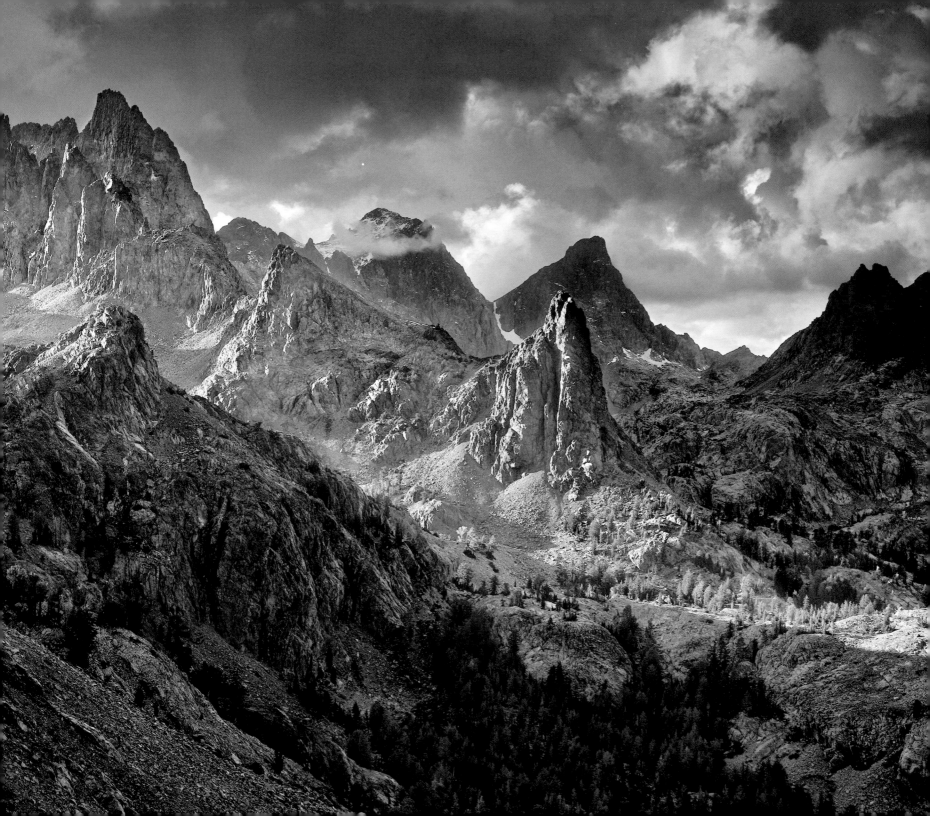

In late June, when the Sierra Nevada's snow melts, the wilderness trails become quite busy as the meadows burst to life. In these higher elevations there isn't a true spring, for by the time the snow melts the temperatures are those of summer. Normally, summer is not the best time for nature photography, because the sun is high and weather conditions are not dramatic. But this is not the case in the Ansel Adams Wilderness. In the early summer, the rivers and waterfalls run high and afternoon thunderstorms often strike, all of which are marvelously photogenic. The wildflowers are glorious, and the crystal clear air and lakes tingle with the energy and freshness of the new season.

At around 9,000 feet, fewer trees grow and they are shorter. Ten thousand feet is about the limit that trees can survive, so above this elevation the landscape takes on a different feel. The marks and polish of the glaciers become more striking without trees or soil to hide them. With the usual cool wind and direct exposure to the elements at this elevation, the world is like a lunar landscape. These high passes are snow-covered except during the summer months, so after July 4, the John Muir Trail fills with avid hikers.

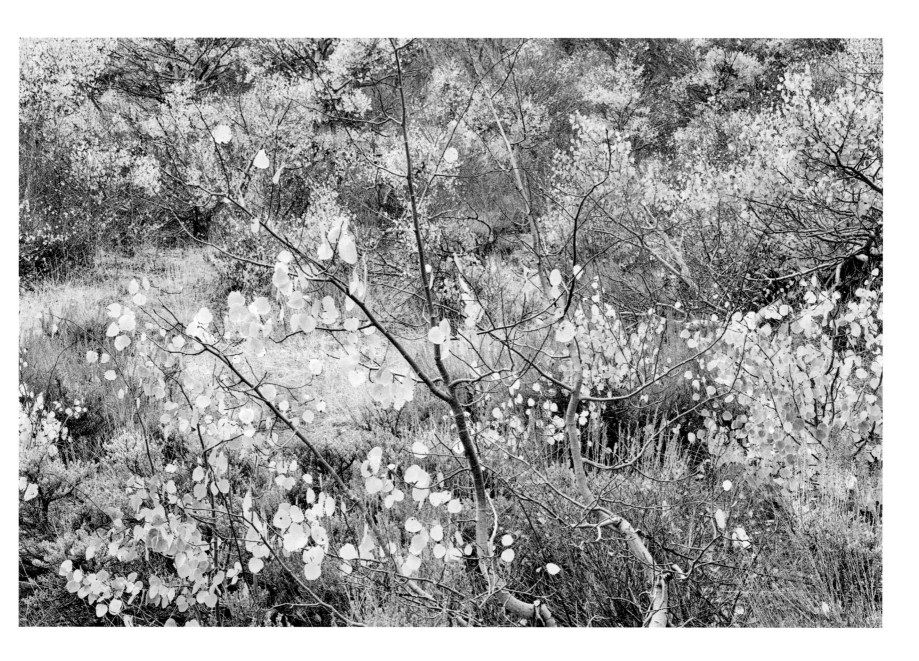

Young aspen trees sprout in a meadow near Parker Lake.

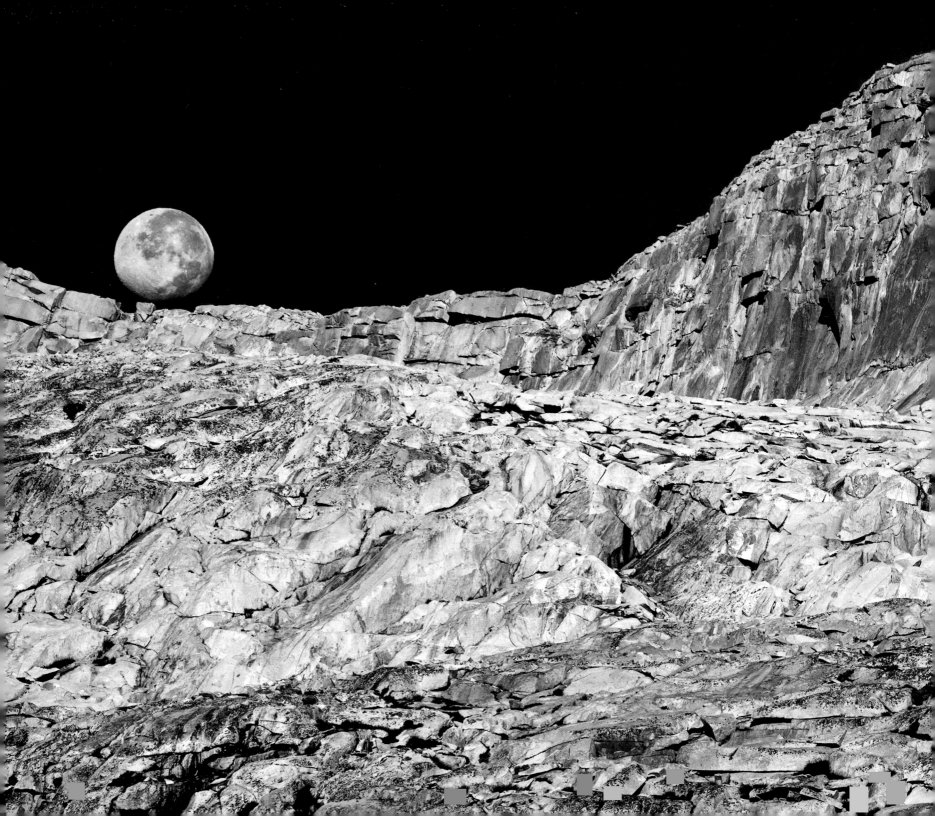

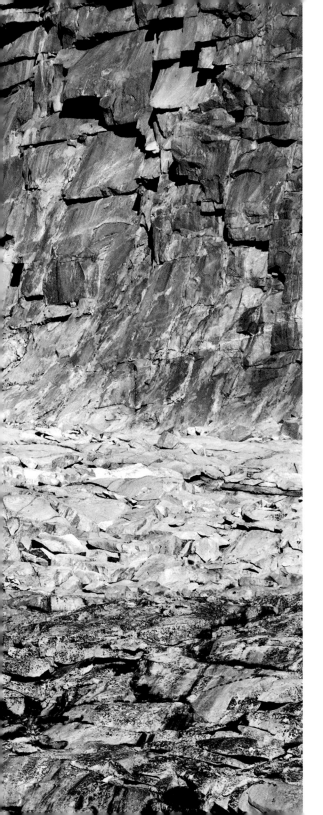

A waning moon sets over the granite cliffs near Donahue Pass.

Every landscape is, as it were, a state of the soul,
and whoever penetrates into both is
astonished to find how much likeness there is in each detail.

~HENRI-FRÉDÉRIC AMIEL

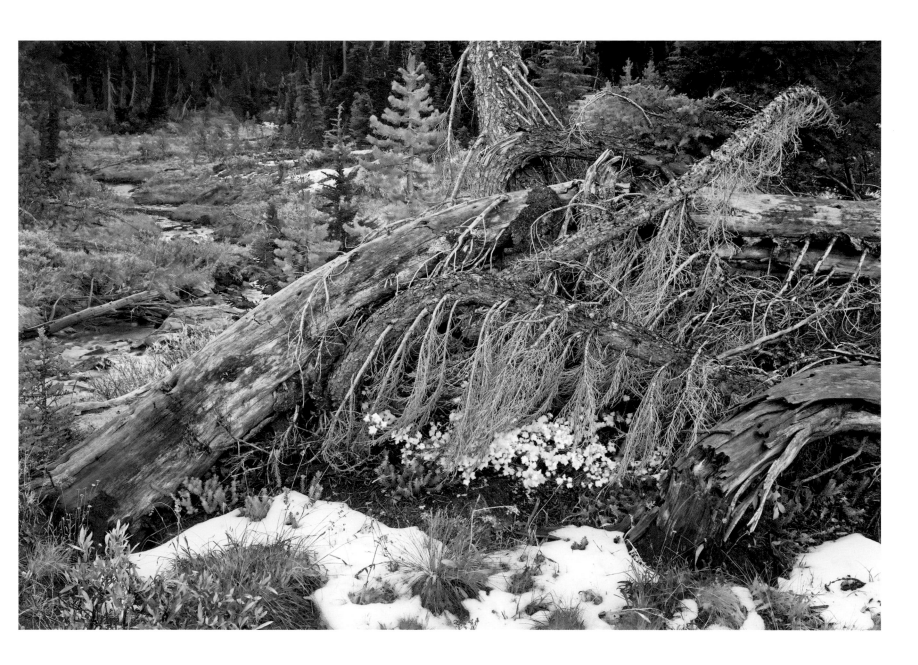

Trees crushed by a past avalanche lie in a meadow near Superior Lake.

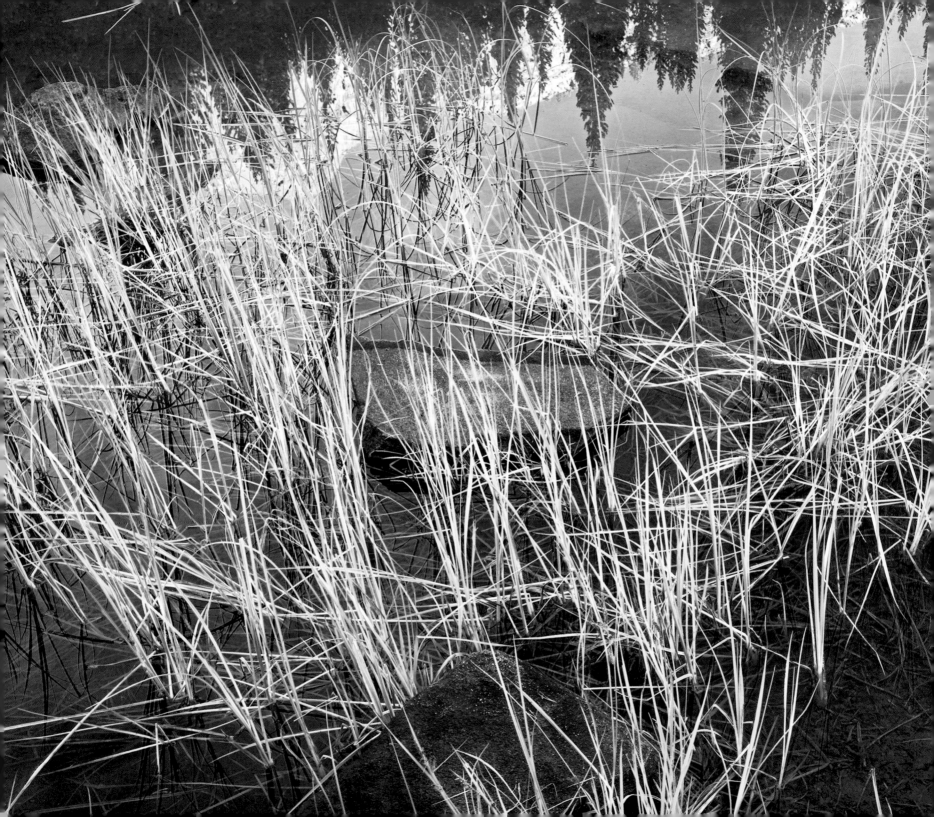

Grasses fill a small pond near Rush Creek.

It's not what you look at that matters, it's what you see.

~HENRY DAVID THOREAU

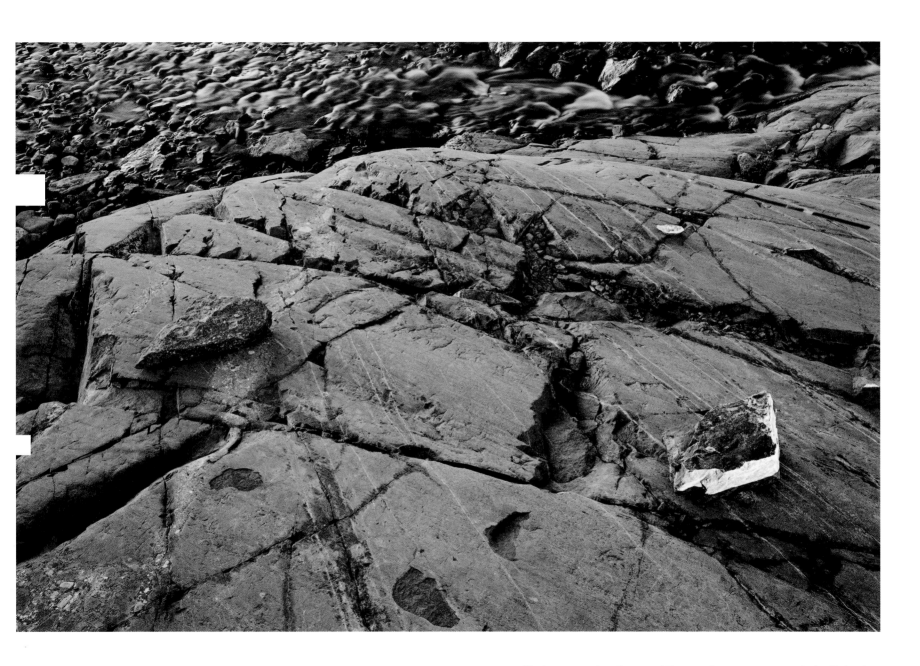

Glaciers carved and scarred the granite on a pass near Lake Catherine.

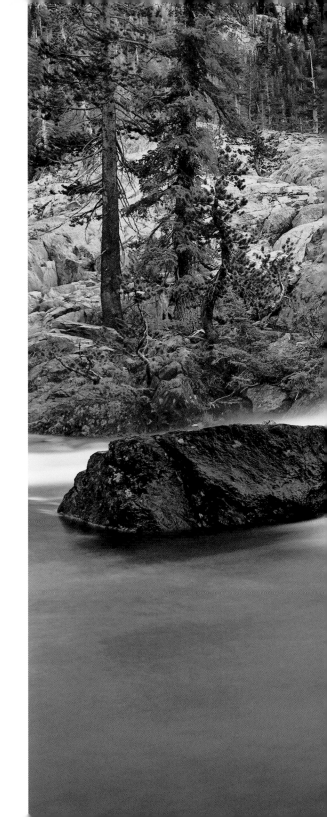

HEADWATERS
and
RIVERS

Summer runoff cascades in Shadow Creek at dusk.

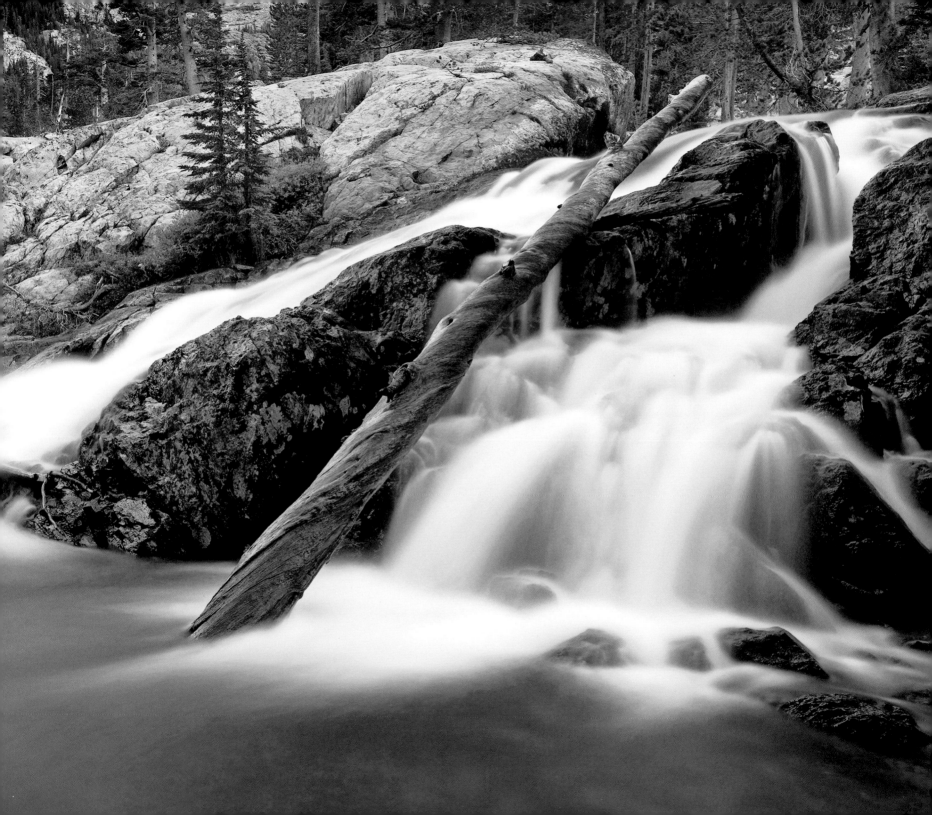

Water is found everywhere in the wilderness, from waves tumbling over falls to creeks and rivers shimmering with patterns of light, to soft, dusk-lit pools after sundown. In Adams's day, it was possible to drink the cool, mountain water simply by dipping in a tin cup. There is a photograph of a young Ansel Adams with the handle of the distinctive Sierra cup under his belt. Now, the water from streams and lakes in the wilderness has to be filtered or boiled before drinking, a sign of human population.

The water from the Middle Fork of the San Joaquin River drains many of the most well-known lakes, such as Thousand Island, Garnet, Ediza, Minaret, and Shadow. The Middle Fork flows north to south and over Rainbow Falls, and then takes a turn to the west where it joins the North and South Forks before ending up in the Mammoth Pool Reservoir. From there it passes through four dams and into the Central Valley, where it often runs dry because of water diversions for agriculture. It then gains replenishment from the Delta-Mendota Canal and other rivers as it flows downstream into the Stockton Deep Water Channel, before eventually draining into San Francisco Bay. What had begun as a wild and vibrantly alive stream at the headwaters settles down to a different kind of river as it drifts into the Pacific Ocean.

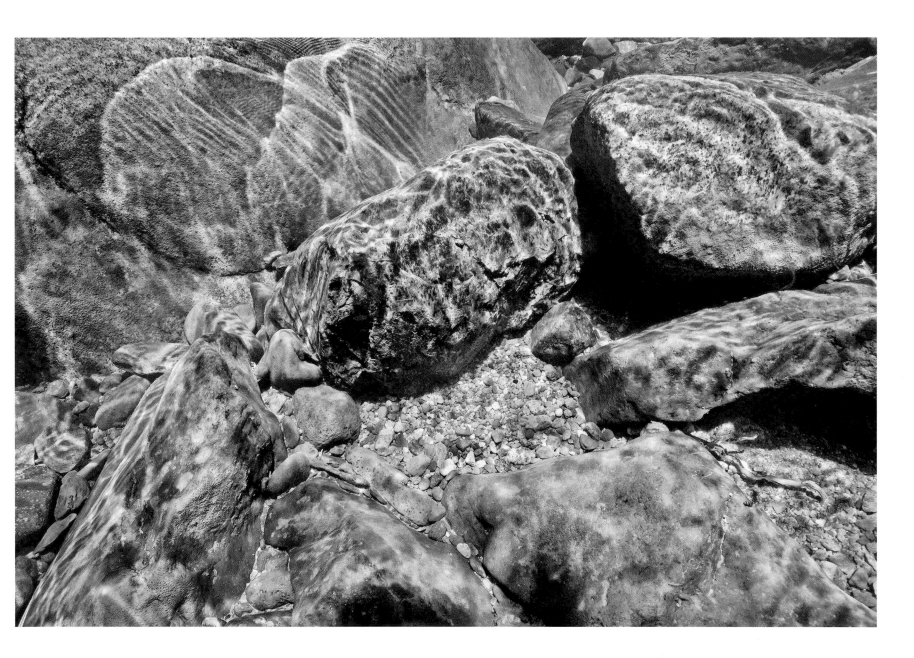

Midday light streams through ripples to the rocky bottom of the San Joaquin River's Middle Fork.

One learns that the world, though made,
is yet being made; that this is still the morning of creation;
that mountains long conceived are now being born,
channels traced for coming rivers, basins hollowed for lakes.

~JOHN MUIR

A small, unnamed waterfall flows near the Marie Lakes.

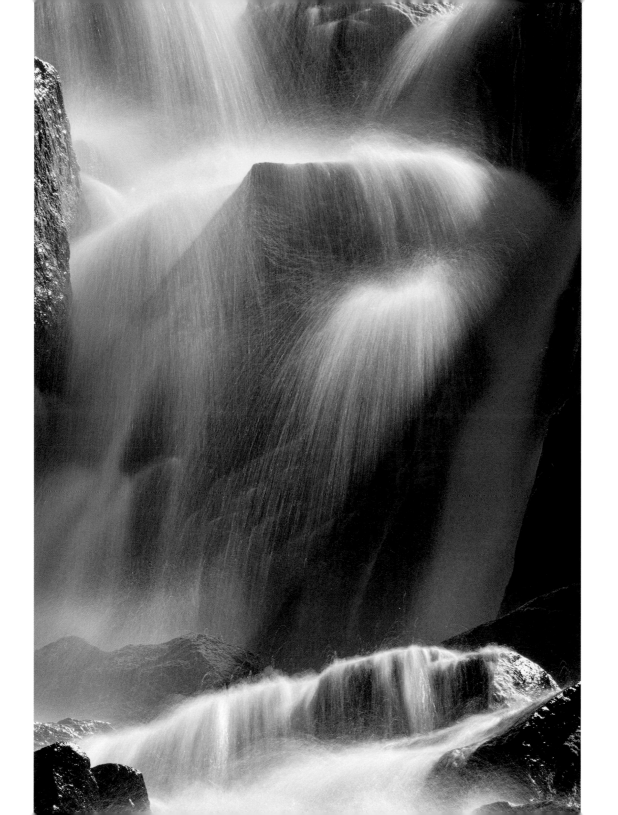

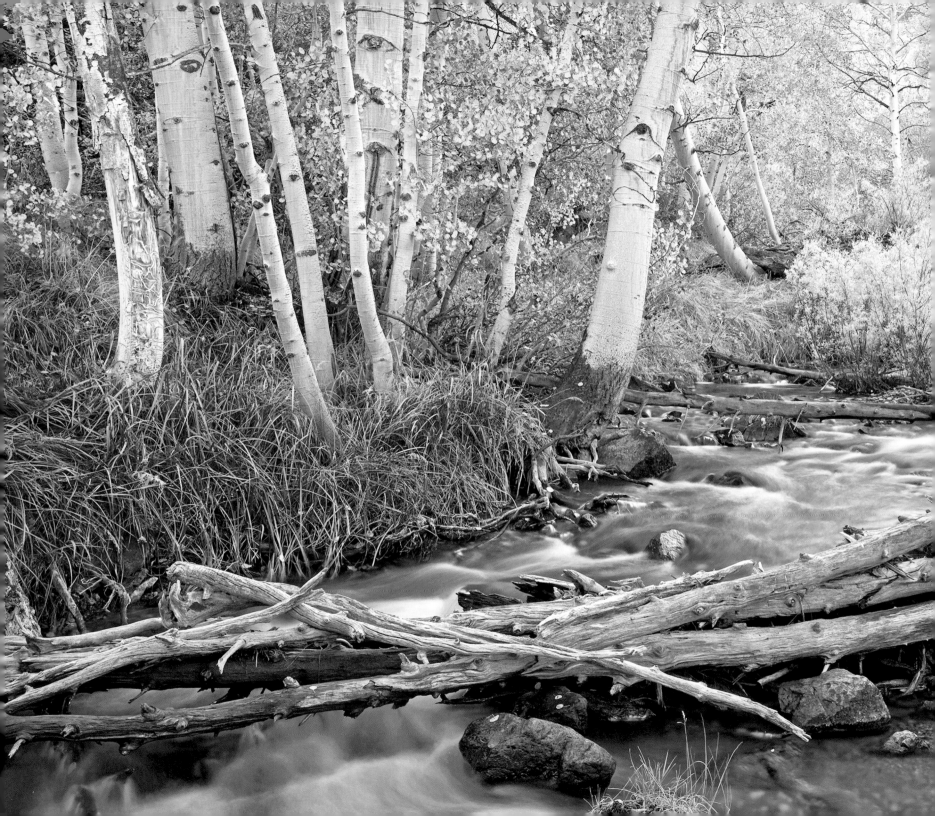

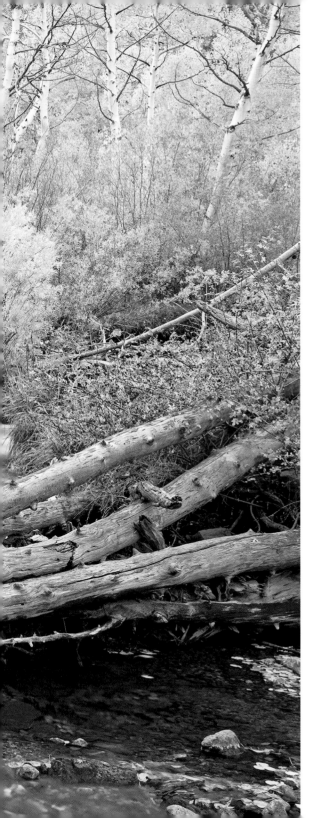

Parker Creek flows past aspens shimmering in the October afternoon light.

And this, our life exempt from public haunt,
finds tongues in trees, books in running brooks,
sermons in stones, and good in everything.

~WILLIAM SHAKESPEARE

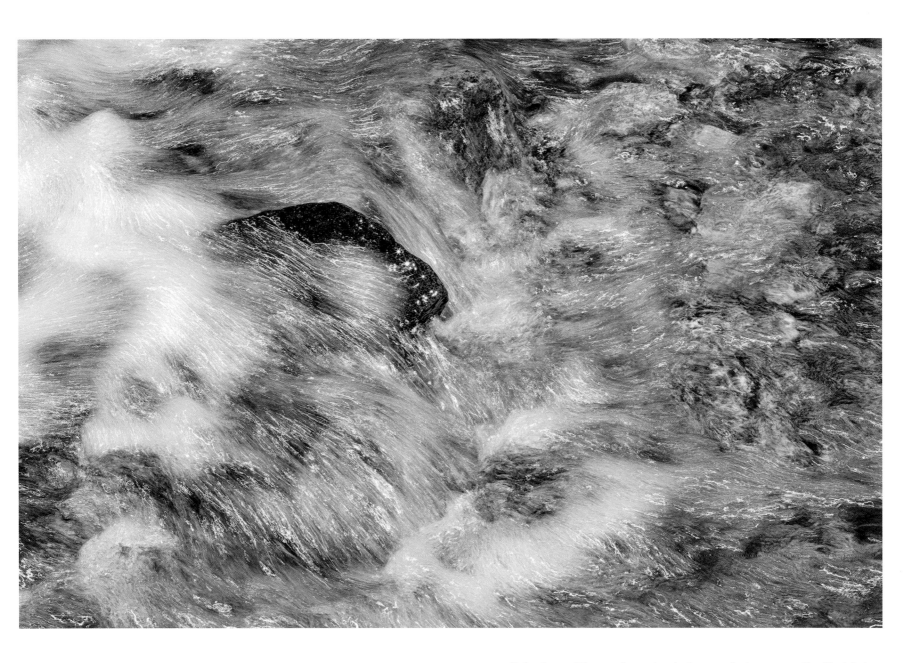

Reflections of the sun form streaks in a small stream near the Clark Lakes.

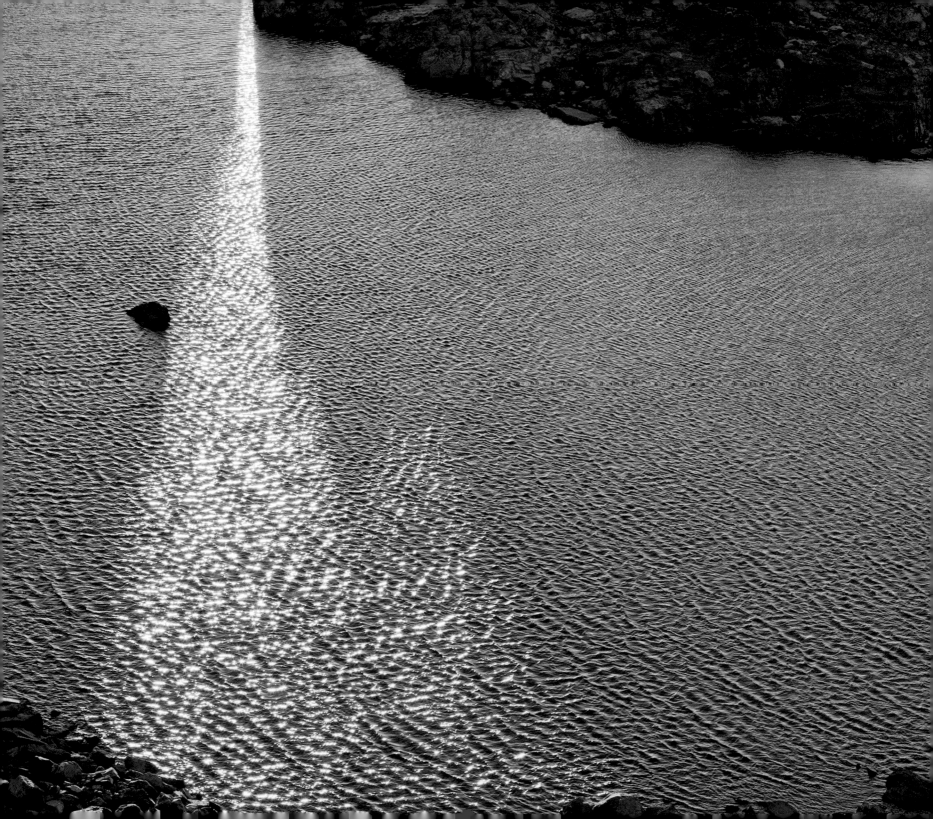

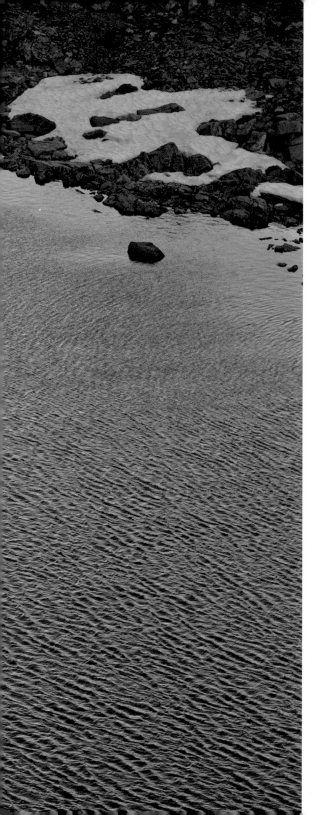

The sun sets over Dana Lake's outflow waters.

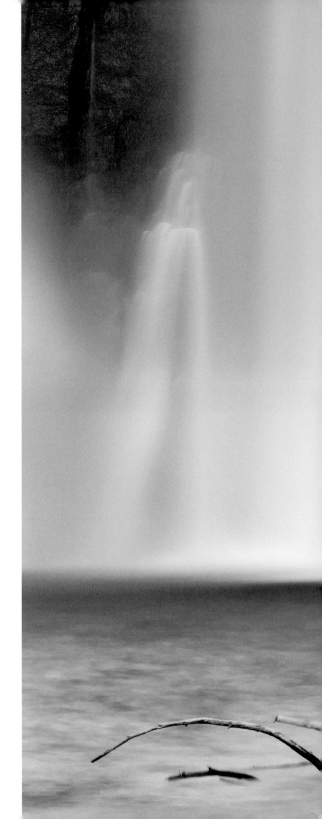

Water from the San Joaquin River's Middle Fork drops over Rainbow Falls.

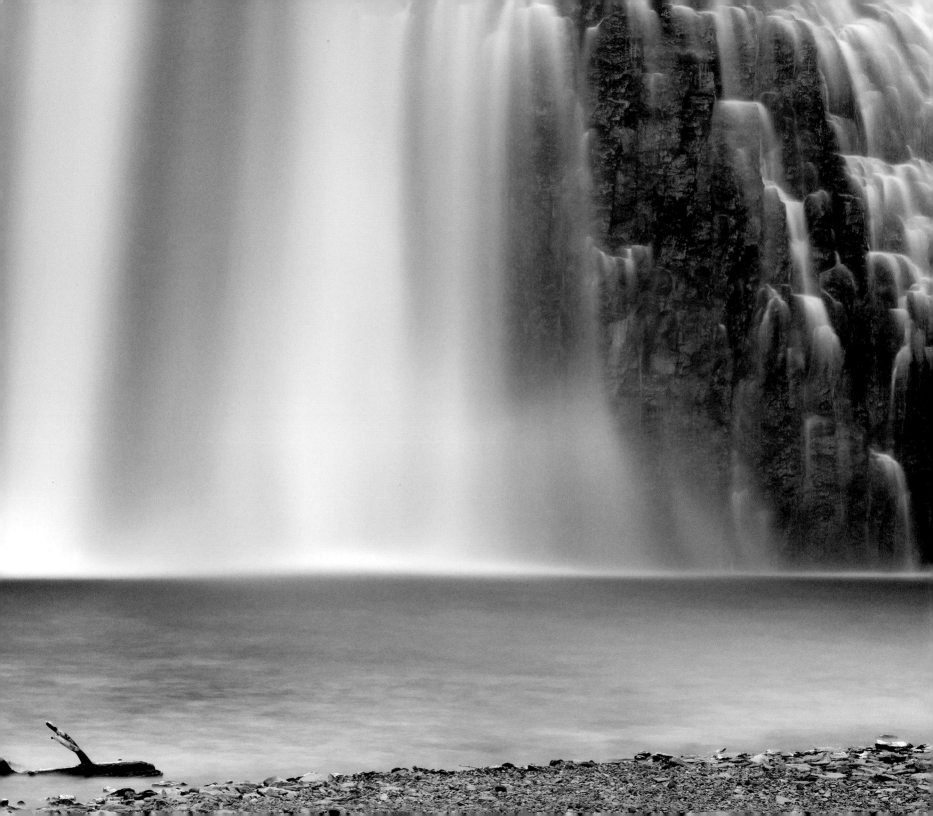

TREES
and
PLANTS

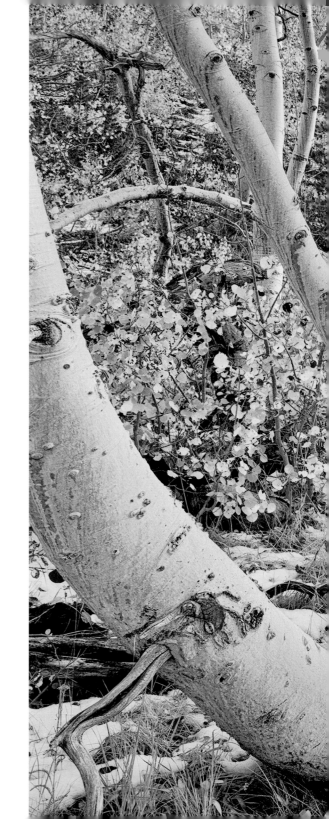

An early snow melts on the forest floor of an aspen grove near Parker Lake.

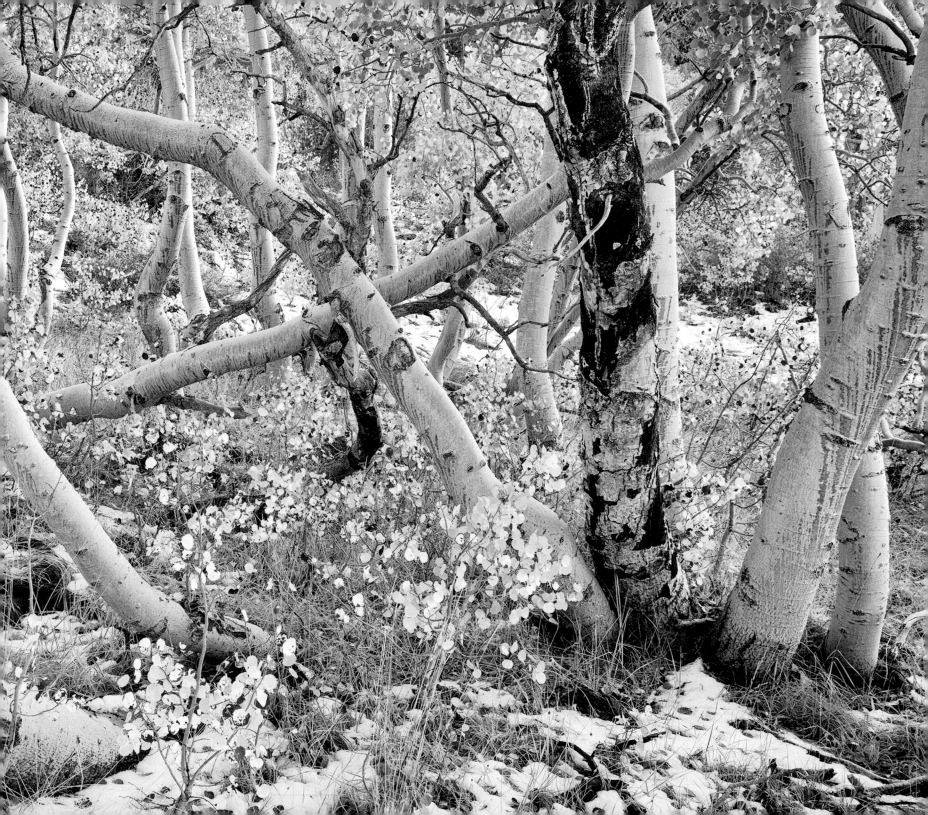

Parker Lake is the only place in the Ansel Adams Wilderness where aspen trees grow, which makes it a "must destination" for the nature photographer in autumn. When I hiked up the trail that runs along Parker Creek to the lake in early October, I could see it was still too early for peak color. Most of the aspen trees were still green. Higher up I found a stand where the leaves had started to turn yellow. I put up camp nearby and during the night an early snowstorm struck the area. That made for one unusual picture. When I returned a week later, the forest was ablaze in yellow and gold.

Aspen trees are always popular subjects for nature photographers. Their vibrant yellows and oranges in autumn seem to scream out "color," but aspens also photograph surprisingly well in black and white. The starkness of the white trunks and the close grouping of the trees in a grove contribute to graphic effects that often lead to successful photographs. The tree trunks near Parker Lake are bigger than most aspens I've encountered. I tried to isolate one large trunk against a sea of leaves. I also liked the fact that the leaves were not uniform in color, so that in black and white, the yellows show a lighter tone than the oranges and the golds.

I am not sure whether Ansel Adams ever photographed the aspen trees at Parker Lake. But in northern New Mexico in 1958, he shot two of the most famous aspen pictures of all time, one vertical and the other horizontal, which are now in museums around the world. These masterpieces of landscape photography set the bar exceedingly high for those who follow.

Moonlight shines on a majestic Sierra Juniper near Shadow Lake.

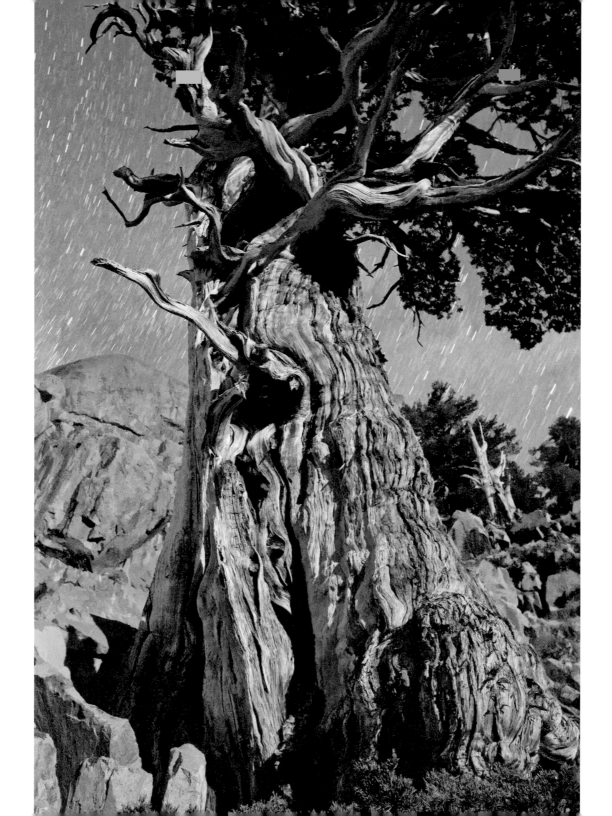

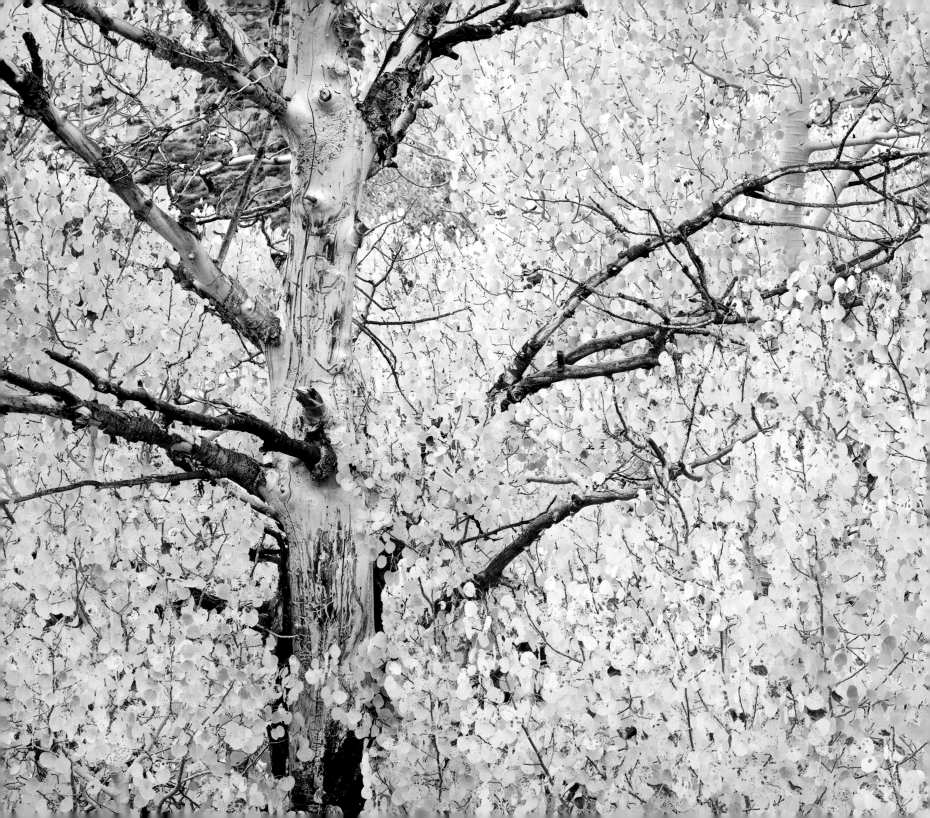

Golden autumn leaves surround an old aspen tree near Parker Lake.

Earth and sky, woods and fields, lakes and rivers,
the mountain and the sea, are excellent
schoolmasters, and teach some of us more than
we can ever learn from books.

~JOHN LUBBOCK

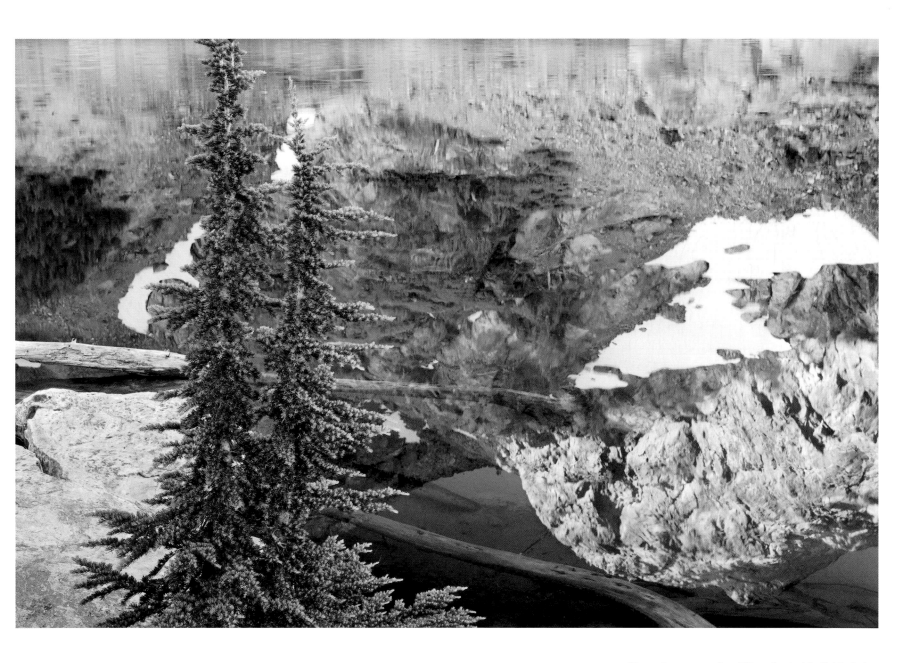

Trees frame granite cliffs reflected in Cabin Lake.

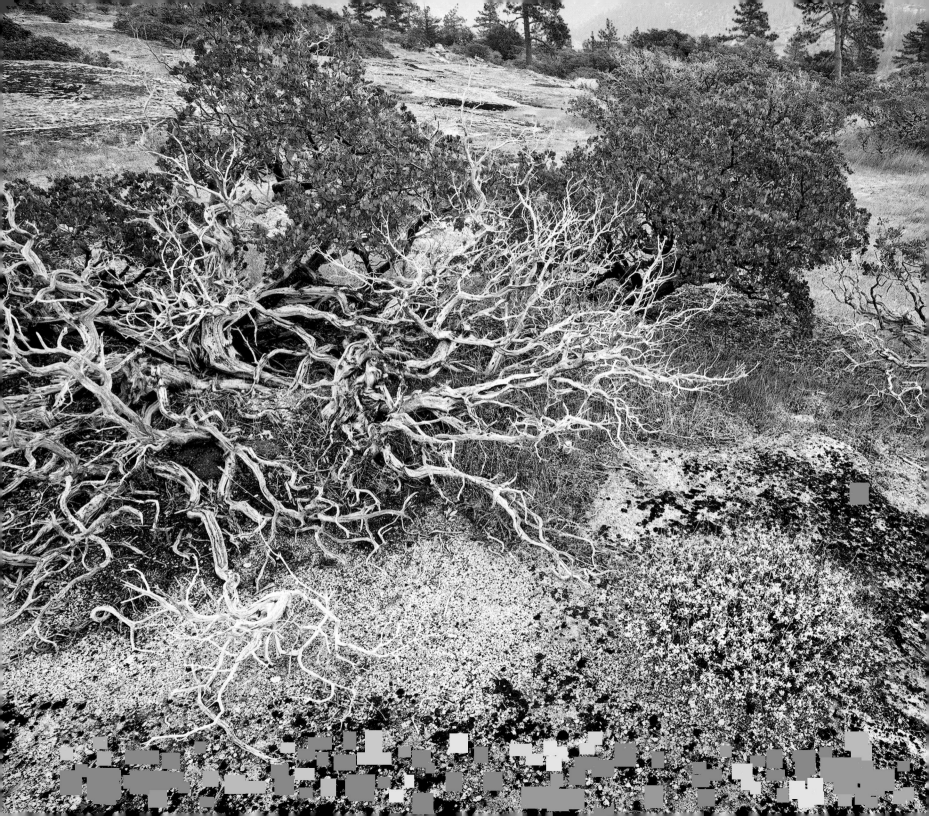

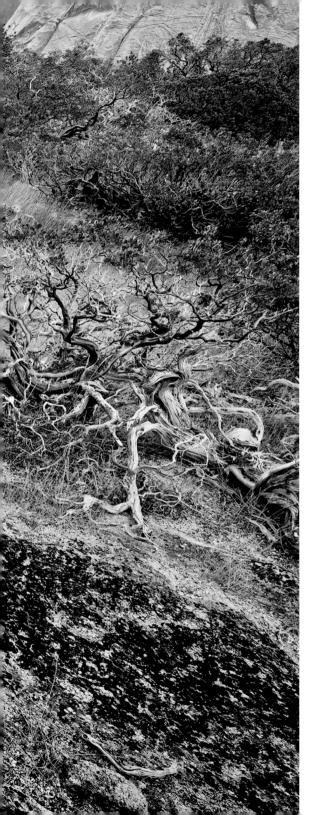

Manzanita trees grow in the San Joaquin River Valley.

Adopt the pace of nature: her secret is patience.

~RALPH WALDO EMERSON

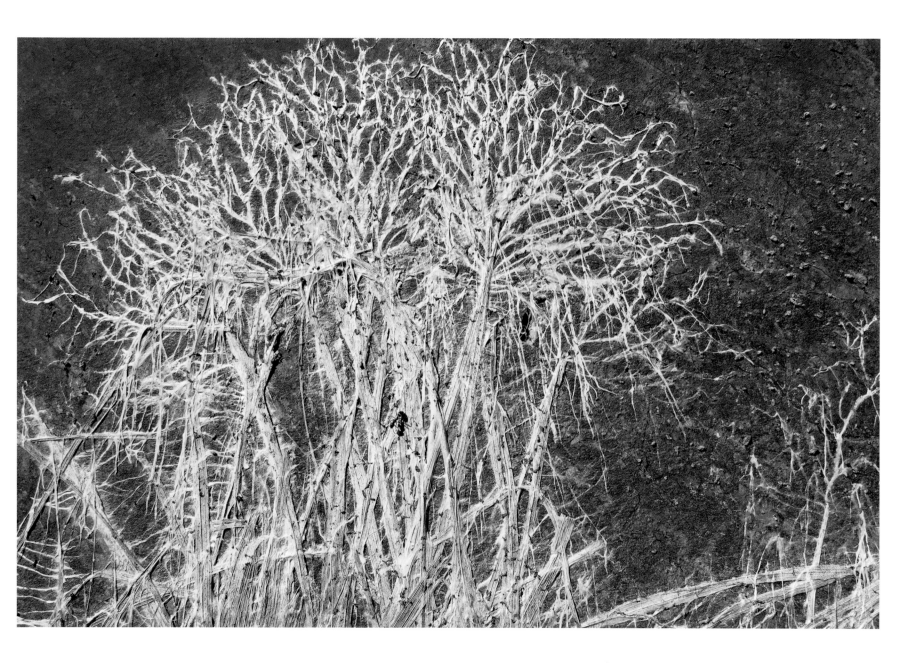

A white fungus outlines a plant flattened against a rock by winter snow.

SNOW
and
WIND

Sleet from an October storm blankets aspen trees near Parker Lake.

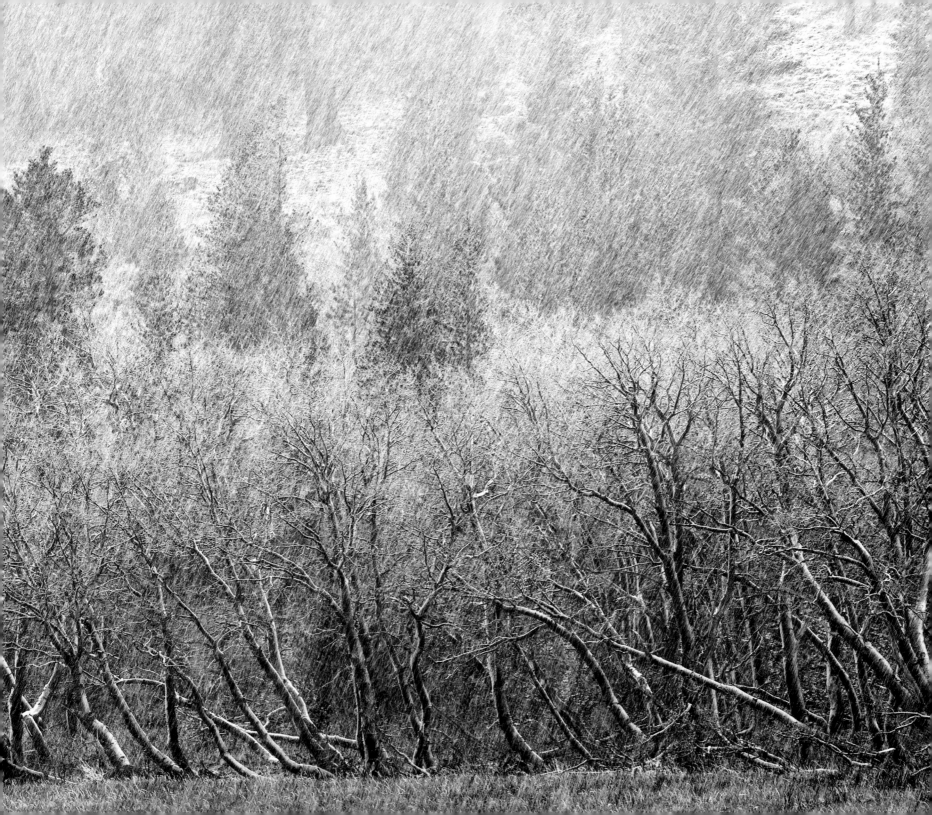

From November to June, much of the Ansel Adams Wilderness is covered in snow. It takes a special effort to photograph the winter backcountry, and fortunately I had two experienced guides to help me. We set out from the parking lot of the June Mountain ski resort on alpine skis suitable for both flat areas and downhill slopes. Our backpacks were laden with food, clothes, and safety gear. The first night we camped near Summit Lake. As the sun set there was a large lenticular cloud—sometimes called a Sierra wave cloud—to the east, a sign of high winds. In the morning the winds had increased, and it was possible to see snow blowing off Rodgers Peak and Mount Lyell in the distance.

We skied to the Clark Lakes and dug a snow cave in anticipation of a forecasted snowstorm, which started to fall just as we finished shoveling. The next day the blizzard hit with full force, and we had no choice but to wait it out in the cave. At one point, I couldn't resist sneaking out for a quick ski to a group of pines for a photograph. The wind was gusting upward of 50 miles an hour and there was limited visibility, but I got the shot. The following day we were able to ski out, arriving safely to our cars, which we found buried under four feet of snow. My adventure to take winter photographs in the Ansel Adams Wilderness proved a test of will and endurance against the formidable forces of nature, which nevertheless won my awe and respect.

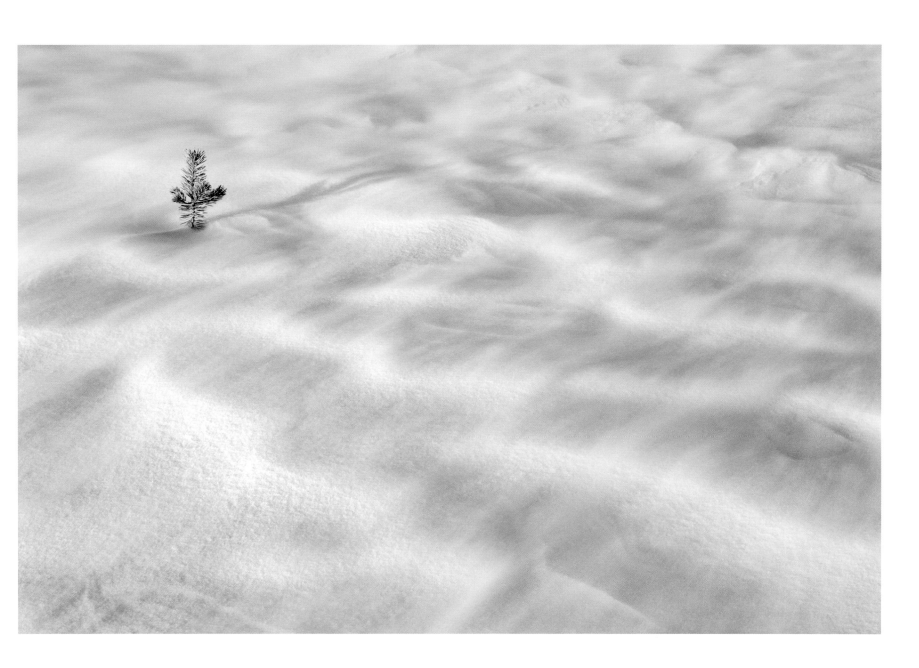

Blowing snow surrounds a pine seedling near Summit Lake.

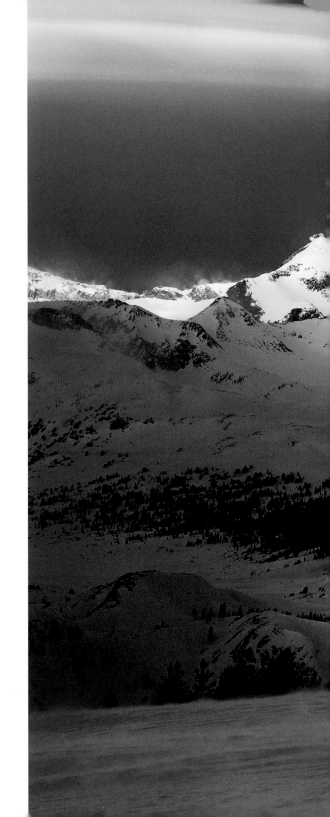

A Sierra wave cloud hangs over Rodgers Peak, left, and Mount Lyell.

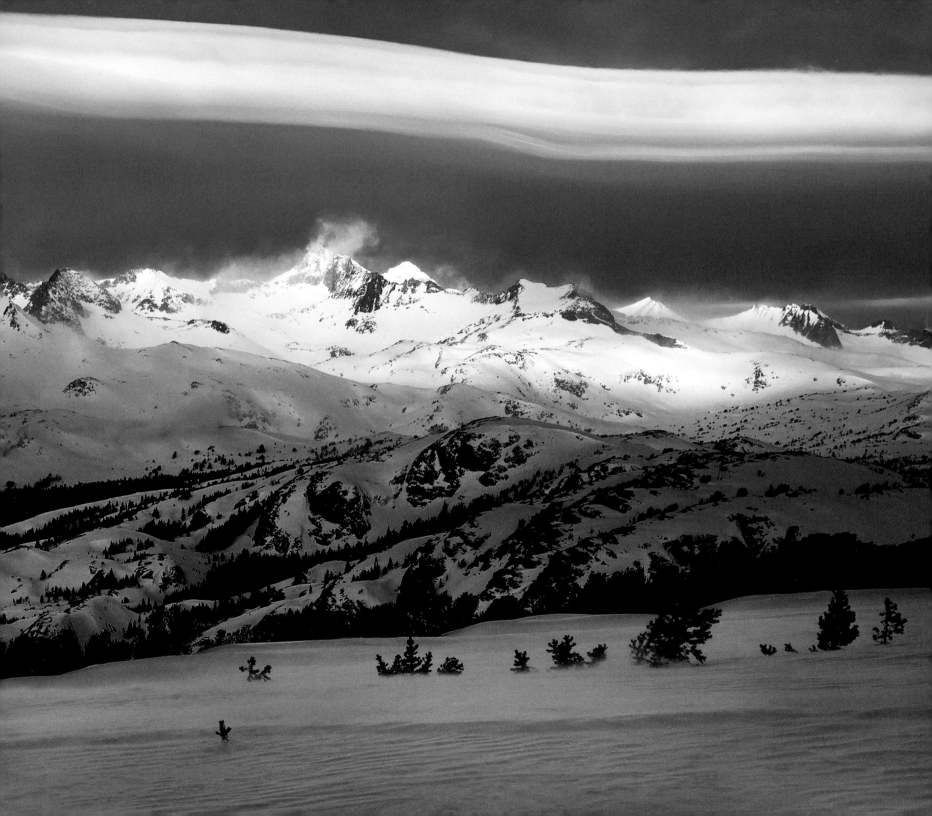

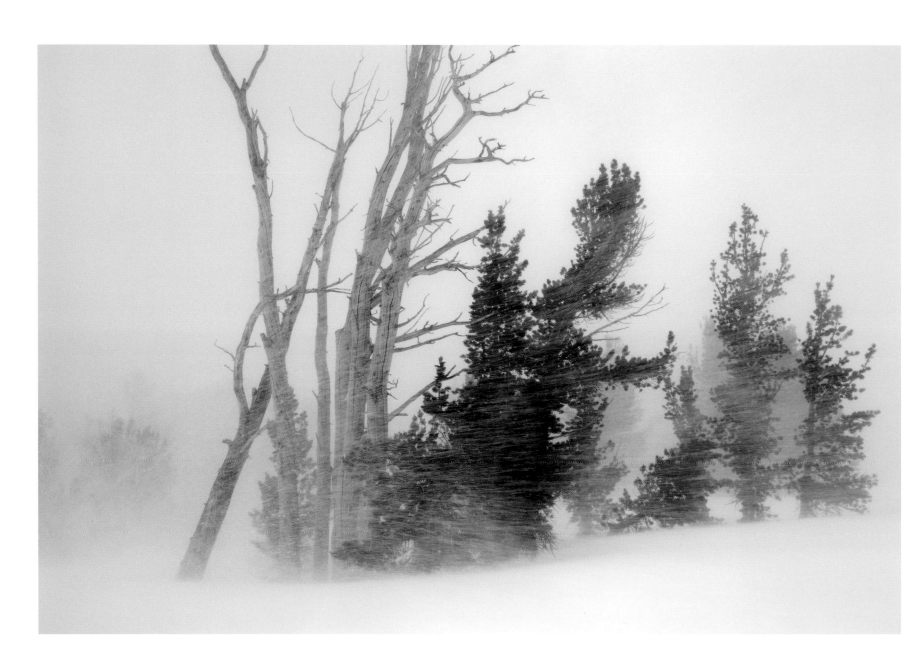

A fierce storm encompasses trees near the Clark Lakes.

A wilderness, in contrast with those areas where
man and his own works dominate the landscape,
is hereby recognized as an area where the earth and its
community of life are untrammeled by man, where
man himself is a visitor who does not remain.

~WILDERNESS ACT OF 1964

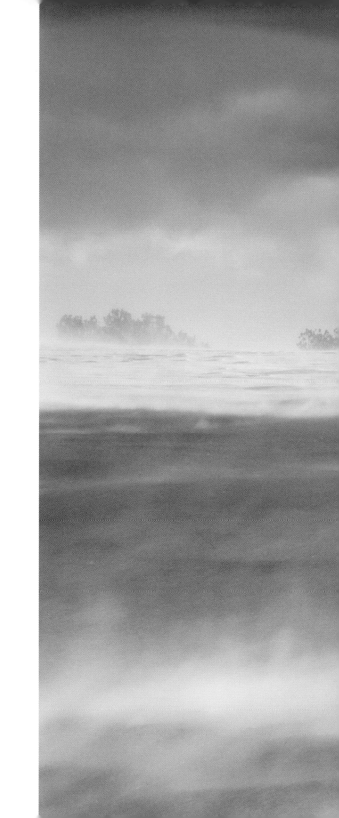

Winds of up to 50 miles an hour move up a ridge near Summit Lake.

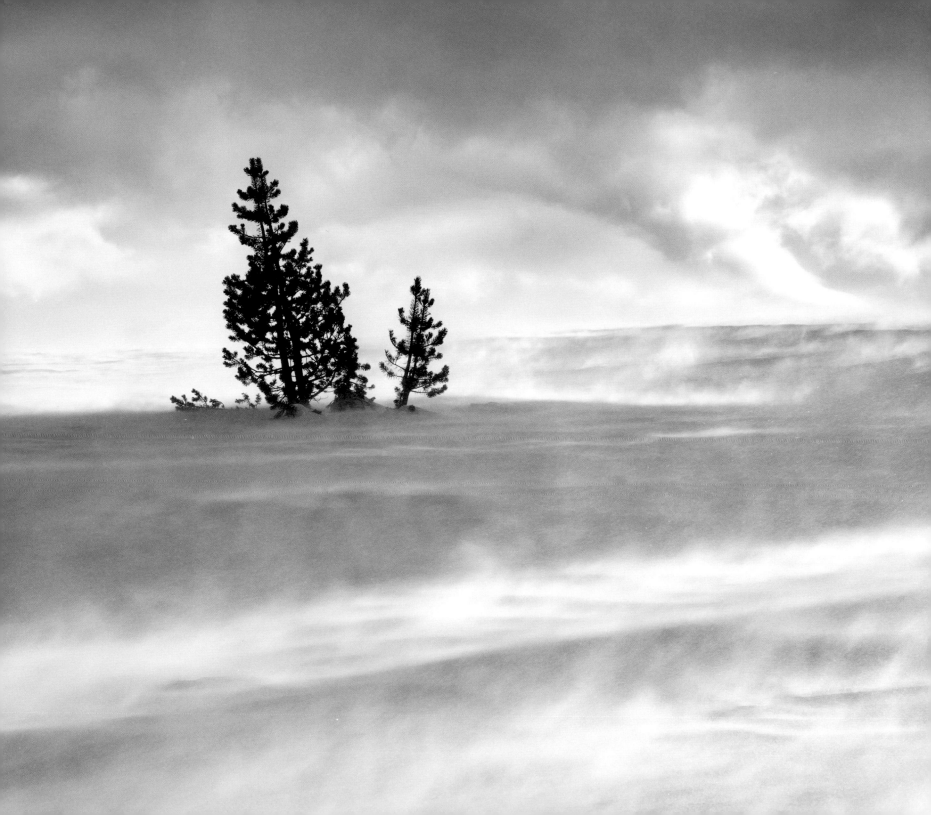

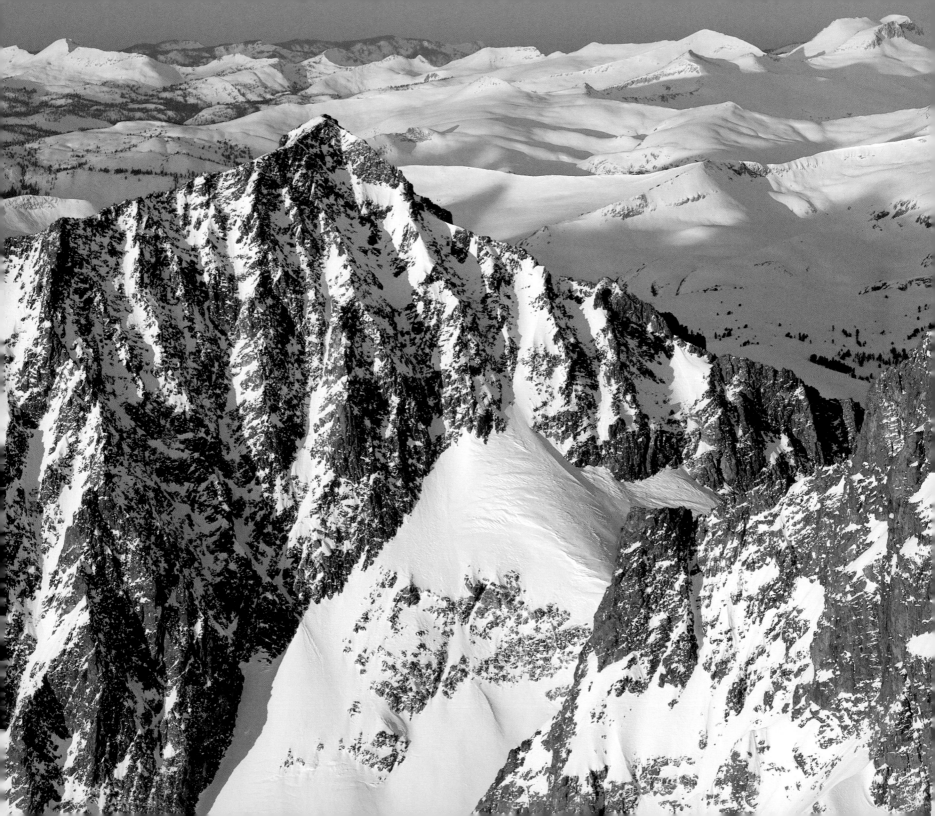

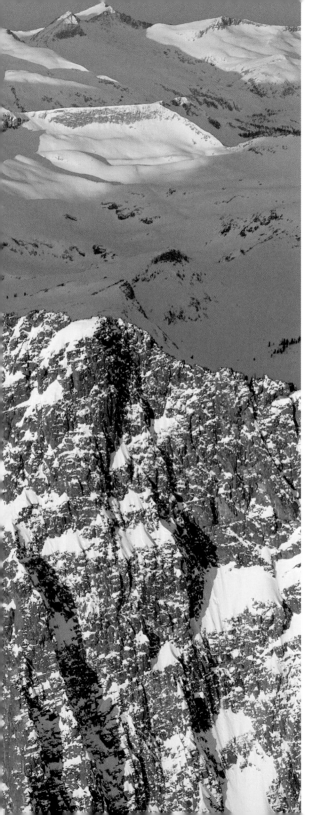

Sunrise shines on the Minarets and the snow-covered Sierra backcountry.

There are no words that can tell the hidden
spirit of the wilderness, that can reveal its mystery,
its melancholy and its charm.

~THEODORE ROOSEVELT

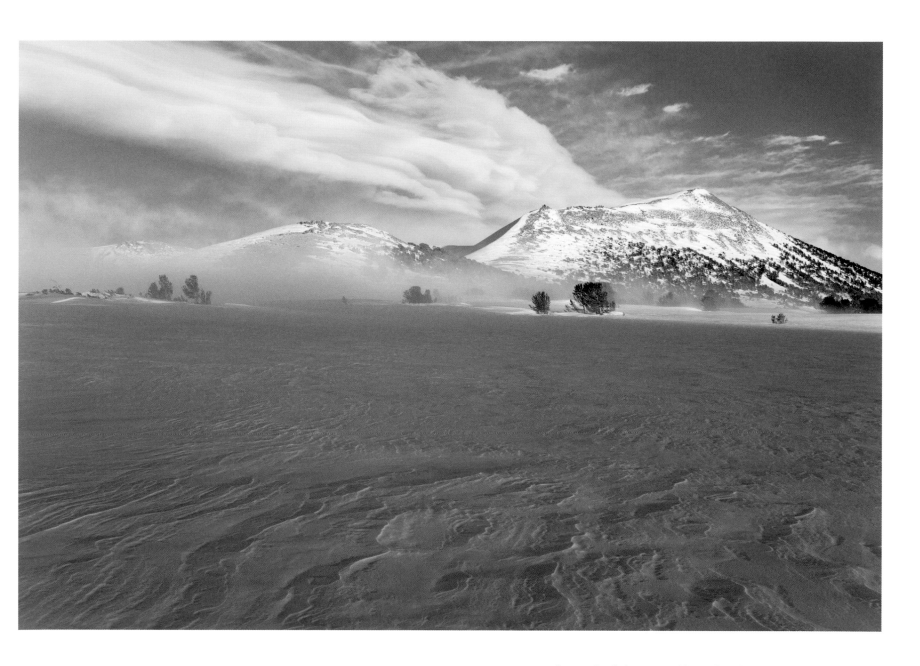

Storm clouds hang over Mount San Joaquin on a winter evening.

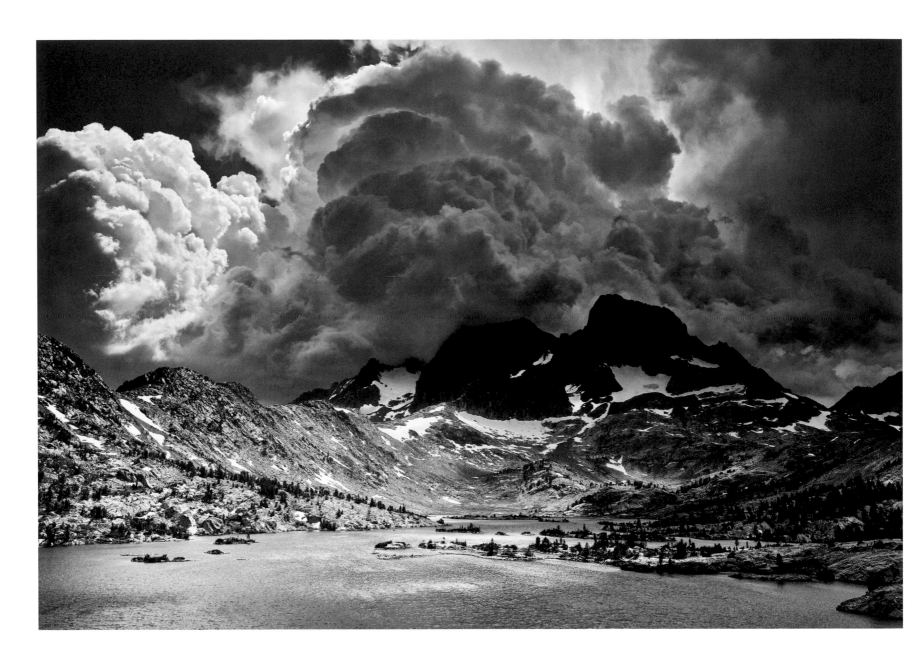

Afternoon thunderclouds rise above Garnet Lake.

INSPIRATION IN THE AGE OF CYNICISM

The times we live in today are radically different from those of the young Ansel Adams who photographed the Sierra wilderness. Times were hard in the 1920s and 1930s, but Americans believed that things would get better and progress would come. Technology in the form of sleek trains and affordable automobiles was seen as a way to make life more comfortable, more exciting. Artists devoted to modernism focused on form as the ultimate expression. Photographers worked free of restrictions and could turn just about anything into a beautiful composition. There was no hidden message or agenda in their work, just the pure delight in seeing. Alfred Stieglitz summed it up by saying that art should be the "affirmation of life." Adams agreed, and he also believed that man could live in harmony with nature.

So what are we to make of Ansel Adams in our era of cynicism? Does it still hold true that art and nature can be inspirational? I believe there will always be the human need for affirmation and inspiration of the kind immortalized by Adams in his Sierra photographs. Our spirits, our own inner beauty, spring from the same source as these rocks, trees, and reflecting waters. We may never achieve a permanent state of living in harmony with nature, but what we gain from such organic interconnectedness with nature is vital, and perhaps more necessary to our psychic survival today than in the quieter past.

I continue to look to nature for answers to the deeper questions, and I believe that nature offers an unlimited source of material for any artist or observer willing to look. It has not even been a century since Ansel Adams carried his view camera on a burro along the trails of the Sierra high country. In the world of nature, that was only yesterday.

PHOTOGRAPHER'S NOTES

When I started the Ansel Adams Wilderness story, I put a lot of thought into what photographic approach to use. At first it seemed appropriate to use a four-by-five view camera and black-and-white film, as Adams had used when he photographed the High Sierra. Then I realized that Adams was a great believer in using the latest technologies in order to achieve his goals. When a panchromatic emulsion became available for his glass plates, he used it to photograph clouds in the mountains. When film became available, he switched so he didn't have to carry the fragile glass plates on his burro.

A year before his death, Adams told an interviewer that he saw electronic capture as being the future of photography and wished he was young again in order to use the new technology to creative ends.

Photographing at night by moonlight is one area where digital capture is superior to film. The sensor is much more sensitive to low light, and the latest cameras and software have reduced the problem of noise in the shadows. Digital equipment also packs lighter compared to a view camera, a significant advantage when one is carrying all the supplies for several days of work. I had the latest digital camera to render the Ansel Adams Wilderness, and I'm sure that if Ansel Adams were photographing today he would have a similar model. Actually, his would probably be better.

FOREWORD - Aspen Leaf and Frost, Parker Lake, 10/22/2010, 8:04 a.m.
CANON EOS-1DS MARK III, 180MM MACRO LENS, ISO 100, 4 SECONDS AT F/22

- -

In late October, I camped in the aspen grove at the far end of Parker Lake. During the night the temperature dropped, and in the morning frost shimmered on some of the aspen leaves nearby. Frost crystals are fractals formed when water goes from liquid to solid. I used a macro lens on a tripod and carefully lined up the elements before locking up the camera mirror for the long exposure at dawn. It is easy to get unwanted camera movement with long exposures of macro scenes, so care must be taken to lock up the mirror and wait for the camera to settle before the exposure begins.

INTRODUCTION - Pines in Snow, 2/27/2011, 4:46 p.m.
CANON 1D MARK IV, 70-200MM LENS, ISO 320, 1/3000 SECOND AT F/8

- -

I wanted to get some aerial photographs of the Ansel Adams Wilderness and was excited to see how the landscape would look from the air right after a large snowstorm. In a Cessna 180, I spotted some pines among the snow near Gem Lake. The afternoon backlight was causing shadows of the trees on the snow to appear almost exactly the same size as the trees themselves. This is a perfectly natural phenomenon that happens every day at this hour, but we are more accustomed to seeing reflections on water that produce this effect. To me, this photograph fits what Adams called an extract, when a photographer captures a portion of the scene in the viewfinder that reflects the emotional response that he or she felt at the time.

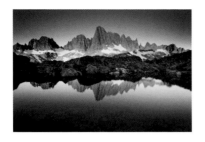

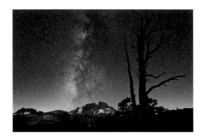

PAGES 16–17 - Minarets, near Cecile Lake, 8/13/2010, 6:18 a.m.
CANON EOS-1DS MARK III, 16-35MM LENS, ISO 200, 1/10 SECOND AT F/11

The Minarets, the centerpiece of the Ansel Adams Wilderness, are difficult to photograph up close. From Cecile Lake, I had hoped to get a reflection of the mountains in the water, but the lake was never calm enough. I found a small pond nearby and realized that at sunrise the water might be calm. The composition lined up with a wide-angle lens, and indeed, the next morning the whole scene lit up for me for a few minutes and with little wind—just enough to show the water's ripples. The exposure was quite straightforward with a 2-stop neutral density filter on the sky to balance the contrast between the areas of sunlight and shadows.

PAGES 18–19 - Milky Way, Banner Peak, 8/4/2010, 12:51 a.m.
CANON 1D MARK IV, 16-35MM LENS, ISO 5000, 30 SECONDS AT F/4

This photograph was taken with light from a crescent moon hitting Banner Peak, but with the foreground tree in shadow creating the silhouette.

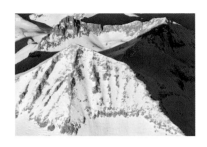

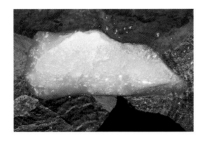

PAGES 20–21 - Mount Ansel Adams,
2/27/2011, 5:30 p.m.
**CANON 1D MARK IV, 70-200MM LENS,
ISO 320, 1/1500 SECOND AT F/8**

- -

Photographed at sunset, Mount Ansel Adams is situated on the wilderness's border with a remote section of Yosemite National Park.

PAGE 23 - Iceberg Lake,
8/13/2010, 1:39 p.m.
**CANON EOS-1DS MARK III, 70-200MM LENS,
ISO 200, 1/90 SECOND AT F/16**

- -

This iceberg was just about a foot across and was moving slowly at the end of Iceberg Lake. I was handholding the medium telephoto lens and followed the iceberg for a few minutes until it disappeared over a cascade.

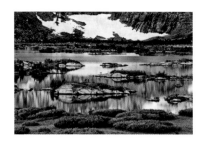

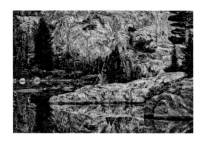

PAGE 24 - Thousand Island Lake,
8/8/2010, 6:22 a.m.
**CANON EOS-1DS MARK III, 70-200MM LENS,
ISO 100, 1/8 SECOND AT F/16**

--

Sunrise is an important time for a nature photographer. Many famous photographs by Ansel Adams were taken at sunrise, including *Sand Dunes, Sunrise, Death Valley, California, 1948; Sunrise, Mt. Tom, Sierra Nevada, California, 1948;* the later masterpiece, *Sunrise, El Capitan, Yosemite National Park, 1968;* and the most famous of all, *Winter Sunrise, the Sierra Nevada, from Lone Pine, California, 1944.* Sunrise is especially important when photographing in the Eastern Sierra. The range is situated north to south, so if you are looking from the east, the best light will always be at sunrise, just as it was this morning at Thousand Island Lake. That is why I photographed at sunrise just about every morning on the Ansel Adams Wilderness assignment.

PAGES 26–27 - Cabin Lake,
8/14/2010, 5:55 a.m.
**CANON EOS-1DS MARK III, 70-200MM LENS,
ISO 200, 8 SECONDS AT F/16**

--

This scene at dawn was flat in contrast and not too striking in color, but the stillness of the water caught my attention, and I took a single frame. The similarity in tone of the granite and the reflection creates the visual effect, but also makes it difficult to print as just a small difference in contrast changes the whole mood.

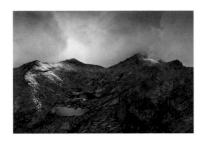

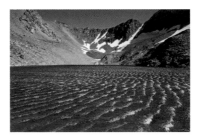

PAGE 28 - Blue Lake,
10/20/2010, 5:20 p.m.
**CANON EOS-1DS MARK III, 16-35MM LENS,
ISO 400, 1/250 SECOND AT F/8**

- -

I was near Mount Ansel Adams when I photographed this remote territory from a helicopter. The sun was setting behind clouds forming along the ridge.

PAGES 30–31 - Wind, Dana Lake,
8/17/2010, 3:35 p.m.
**CANON 1D MARK IV, 16-35MM LENS,
ISO 200, 1/250 SECOND AT F/8**

- -

Dana Lake can be a windy place. For this photograph the wind was howling at about 30 miles an hour. The sky was cloud free, but the lake had whitecaps—something I had never expected to see moving across a High Sierra lake. The picture conveys an incongruous feeling with the top rather static and the bottom half filled with motion. Wind is often difficult to capture in a still photograph. It is implied in some of the increasingly popular time-lapse sequences by movement of clouds, but the overall effect is more of time passing and the changes from day to night. Thus this photograph of summer wind becomes a keeper, as it tells a story about the Ansel Adams Wilderness that has not been told elsewhere.

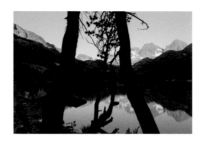

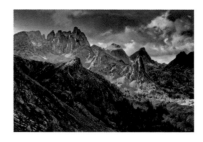

PAGE 33 - Shadow Lake,
8/15/2010, 6:22 a.m.

**CANON EOS-1DS MARK III, 16-35MM LENS,
ISO 100, 1/15 AT F/16**

- -

Here the scene's contrast was so great that I combined two images into a High Dynamic Range (HDR) file in Photoshop. I used one RAW file that was a normal exposure for the background, and a second RAW file exposed two stops brighter to get detail in the section of the lake in shadow and a hint of detail in the foreground trees. I tried to retain the overall mood of being in the shadows looking up to sunlight on the peaks. With HDR software, it would be possible to get full detail on the foreground trees, but I have found that this often produces an artificial look.

PAGES 34–35 - Minarets, from Nancy Pass,
10/12/2010, 4:43 p.m.

**CANON EOS-1DS MARK III, 24-105MM LENS,
ISO 100, 1/20 SECOND AT F/16**

- -

I made a nine-mile hike alone in October and camped at Superior Lake at the base of Nancy Pass. The next morning I carefully made the 500-foot climb to the pass with a full pack and camera gear. At the top, there was just a little ledge to set up a tent, but I did so quickly and then started photographing. There was an afternoon storm that was clearing, and sunlight streaming in from just above and behind the Minarets. I used a 2-stop neutral density filter to darken the sky and enhance the mood of the scene.

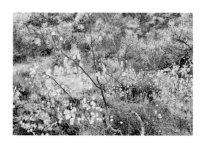

PAGE 37 - Young Aspens, near Parker Lake, 10/23/2010, 4:07 p.m.

CANON EOS-1DS MARK III, 24-105MM LENS, ISO 100, 1/30 SECOND AT F/16

- -

I increased the contrast somewhat in the print and made the foreground leaves lighter than those in the background. The light was diffused sunlight.

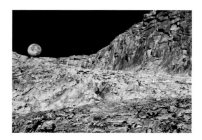

PAGES 38–39 - Moonset, near Donahue Pass, 8/27/2010, 7:09 a.m.

CANON EOS-1DS MARK III, 70-200MM LENS, 2X EXTENDER, ISO 400, 1/180 SECOND AT F/22

- -

Each month, the full moon rises over the eastern horizon at exactly the same time as the sun sets in the west. So if you want to photograph the moon rising with sunlight on the landscape in the foreground, the best time is two days before the actual full moon. Then, the waxing moon will look almost full, but it will have been up for two hours because the moon rises one hour later each day. It also moves about 15 degrees each hour, so it will be about 30 degrees above the horizon. The same effect happens in reverse with the moon setting. Two days after the full moon it is possible to photograph the sunrise light hitting on the landscape with the waning, almost full moon still 30 degrees above the western horizon.

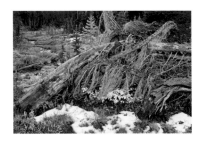

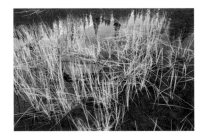

PAGE 41 - Fallen Trees, near Superior Lake, 10/11/2010, 5:46 p.m.

CANON EOS-1DS MARK III, 24-105MM LENS, ISO 100, 7/10 SECOND AT F/16

These trees had been crushed by an avalanche. The mood of the dusk scene is somber, long after the sun had left the deep valley.

PAGES 42–43 - Pond, near Rush Creek, 8/25/2010, 6:38 a.m.

CANON EOS-1DS MARK III, 16-35MM LENS, ISO 125, 1 SECOND AT F/16

Sunrise light on the mountains reflected in a pond full of grasses. This is a scene of high contrast but within the range of a single RAW capture.

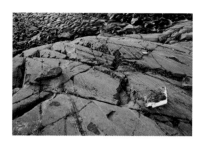

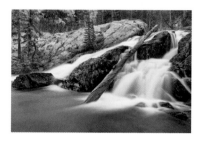

PAGE 45 - Rock, near Lake Catherine, 8/6/2010, 6:48 a.m.

CANON EOS-1DS MARK III, 16-35MM LENS, ISO 50, 2 SECONDS AT F/16

Several places in the Ansel Adams Wilderness show where glaciers have carved and scraped the granite below. This photograph was taken right after sunrise, where the early light hit on the side of a few loose rocks before illuminating the whole surface of the bedrock.

PAGES 46–47 - Shadow Creek, 8/8/2010, 7:54 p.m.

CANON EOS-1DS MARK III, 16-35MM LENS, ISO 50, 20 SECONDS AT F/16

I got to Shadow Creek as it was getting dark, but the creek still had a glow. I came to a small waterfall with a log resting on a rock in the middle. The indirect light at dusk set a beautiful mood, and I was able to capture the scene in the low light with a long exposure that blurred the water in the cascade.

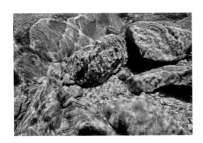

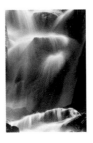

PAGE 49 - Middle Fork of the San Joaquin River, 8/1/2010, 1:36 p.m.
CANON 1D MARK IV, 17-40MM LENS, ISO 200, 1/45 SECOND AT F/16

While imagining new and different ways to view a wilderness area, I decided to try some underwater photos. Water is such an important feature of the High Sierra that I thought I should show what nature looks like on the bottom of a stream or lake. There is one area near the campground in Devils Postpile National Monument where it is possible to walk with my heavy Sea and Sea underwater housing from my car into the Ansel Adams Wilderness and to the Middle Fork of the San Joaquin River. I found an area with a manageable current and some granite rocks on the bottom, patterned with light. Such patterns form in the middle of the day, when the sun passes through the ripples on the river's surface.

PAGE 51 - Waterfall, near the Marie Lakes, 8/26/2010, 2:22 p.m.
CANON EOS-1DS MARK III, 70-200MM LENS, ISO 50, 2 SECONDS AT F/22

In this shot, I used a polarizing filter, a slow ISO, and a small f stop in order to show movement of the water in addition to the diagonal shadow from the backlight.

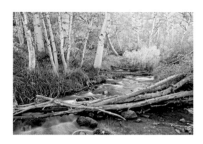

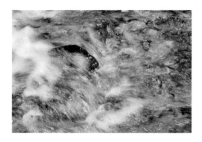

PAGES 52–53 - Parker Creek,
10/22/2010, 5:07 p.m.
**CANON EOS-1DS MARK III, 16-35MM LENS,
ISO 50, 3 SECONDS AT F/16**

- -

Diffused afternoon light hit the aspens in the background while the creek was in shadow. In making the print I lightened the foreground a bit, but still kept the background trees lighter so that the eye follows the creek through the frame. In Photoshop it was possible to lighten the golden leaves, using the digital equivalent of a yellow filter when I made the black-and-white RAW conversion.

PAGE 55 - Stream near the Clark Lakes,
8/2/2010, 11:34 a.m.
**CANON EOS-1DS MARK III, 70-200MM LENS,
ISO 50, 1/20 SECOND AT F/22**

- -

Here I shot in full sunlight with a relatively slow exposure. The white streaks are the movement of the sun's reflection in the moving water.

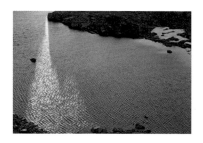

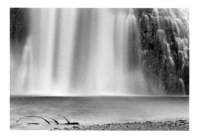

PAGES 56–57 - Evening Light, below Dana Lake, 8/17/2010, 7:33 p.m.
CANON 1D MARK IV, 70-200MM LENS, ISO 200, 1/60 SECOND AT F/13

The sun was just above the top of the frame, so I had to carefully shield the lens to avoid unwanted flare.

PAGES 58–59 - Rainbow Falls, 8/22/2010, 6:26 p.m.
CANON EOS-1DS MARK III, 70-200MM LENS, ISO 50, 20 SECONDS AT F/22

This picture resulted from long exposure in the full shade of the canyon as the sun was setting.

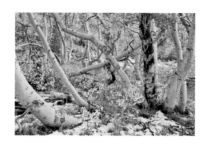

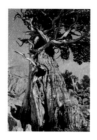

PAGES 60–61 - Snow, Aspens near Parker Lake, 10/9/2010, 4:43 p.m.
CANON EOS-1DS MARK III, 24-105MM LENS, ISO 100, 1/6 SECOND AT F/16

- -

This photo illustrates the typically short transition period between seasons. The fall aspens were just turning gold, but an early snow fell the night before, then melted the next day. The afternoon light is diffused but still creates dimension on the tree trunks.

PAGE 63 - Sierra Juniper, near Shadow Lake, 8/14/2010, 9:02 p.m.
CANON EOS-1DS MARK III, 16-35MM LENS, ISO 3200, 178 SECONDS AT F/5.6

- -

When I saw this magnificent Sierra Juniper, the sun had set and I feared I had missed my shot. Then a faint shadow appeared on the bark—light from a crescent moon setting in the west. As the ambient light darkened, the moonlight became more apparent, but the moon was about to drop below the horizon. Luckily I managed four frames where the moonlight balanced the twilight. The last and best exposure was for three minutes, which is about the maximum exposure possible on my digital camera without getting unacceptable noise.

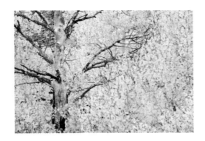

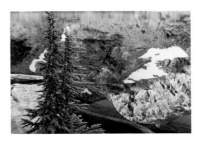

PAGES 64–65 - Aspen Tree, near Parker Lake, 10/21/2010, 2:46 p.m.

CANON EOS-1DS MARK III, 24-105MM LENS, ISO 100, 1/20 SECOND AT F/16

- -

In the print I tried to accentuate the subtle differences in tone in the aspen leaves.

PAGE 67 - Sunrise, Cabin Lake, 8/14/2010, 6:24 a.m.

CANON EOS-1DS MARK III, 50MM MACRO LENS, ISO 200, 1 SECOND AT F/16

- -

This particular morning at Cabin Lake caught me in an experimental mood, trying to find compositions in the reflections of granite and trees by the shoreline. The lake is off the beaten track and seems to define for me what wilderness is all about.

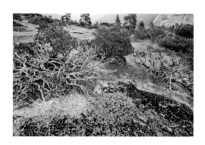

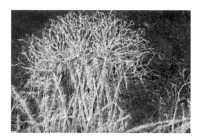

PAGES 68–69 - Manzanitas, near
Hells Half Acre, 8/20/2010, 6:23 a.m.
**CANON EOS-1DS MARK III, 16-35MM LENS,
ISO 125, 1 SECOND AT F/16**

- -

This area was added when the Minarets
Wilderness was enlarged and named
for Ansel Adams in 1984. It is in the San
Joaquin River Valley at a lower elevation
than the rest of the wilderness, hence the
manzanitas and drier vegetation. I pho-
tographed this just as the sun was rising
over the valley in the background.

PAGE 71 - Plant and Fungus,
8/5/2010, 11:06 a.m.
**CANON EOS-1DS MARK III, 16-35MM LENS,
ISO 160, 1/250 SECOND AT F/16**

- -

On the far end of Thousand Island Lake,
I discovered this impression of a small
plant flattened on a rock. A white fungus
had outlined the plant and a single ant
was moving in and out of the frame.

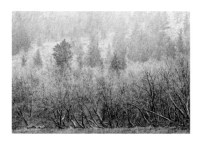

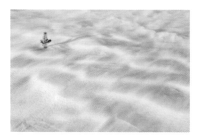

PAGES 72–73 - Sleet, near Parker Lake, 10/24/2010, 9:10 a.m.
CANON EOS-1DS MARK III, 70-200MM LENS, ISO 160, 1/60 SECOND AT F/11

- -

I've found from experience that it is best to photograph rain, sleet, or snow with a medium telephoto lens, and the weather event has to be quite strong for the streaks to show up. I have shot pouring rain from inside a car with the window slightly rolled down, or from under a building overhang. Out in the wilderness, I ducked under a large tree and put a stuff sack over the top of the lens. A shutter speed of 1/60 of a second is usually a good place to start to show a streak movement for photographing with a medium telephoto. I like the effect best when it shows a slight movement. At about 1/1000 of a second or faster, the rain or snow just looks like dots, and slower than 1/8 of a second, the effect usually completely disappears.

PAGE 75 - Pine Seedling, near Summit Lake, 2/24/2011, 7:27 a.m.
CANON EOS-1DS MARK III, 24-105MM LENS, ISO 50, 1/45 SECOND AT F/16

- -

I used a relatively slow shutter speed in order to show some movement of the blowing snow.

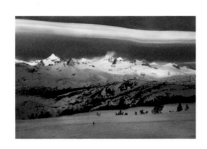

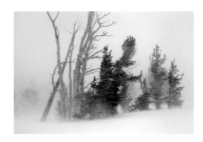

PAGES 76–77 - Rodgers Peak, Mount Lyell, 2/24/2011, 6:55 a.m.
CANON EOS-1DS MARK III, 24-105MM LENS, ISO 100, 1/45 SECOND AT F/11

On a winter trip I camped near the Sierra Divide, and when I got up to take pictures at sunrise, the wind was blowing at about 50 miles an hour. I was excited to see mountains with snow blowing off the ridges and a large wave cloud over them. I had to weigh my tripod down with my backpack and then hold it down in the snow as I made exposures. The light hit the wave cloud, the peaks, and finally the blowing snow where I was standing. It was a beautiful sight, but one that was hard to enjoy given the elements.

PAGE 78 - Snowstorm, near the Clark Lakes, 2/25/2011, 2:43 p.m.
CANON EOS-1D MARK IV, 24-105MM LENS, ISO 100, 1/60 SECOND AT F/11

The wind was gusting upward of 50 miles an hour with limited visibility. Sometimes the trees completely disappeared in a whiteout, but at other times they became faintly visible. I experimented with different shutter speeds, and 1/60 of a second seemed to show the streaks of snow best, which of course show up better against a black background.

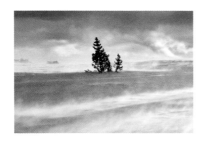

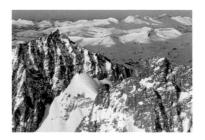

PAGES 80–81 - Wind, near Summit Lake,
2/24/2011, 7:36 a.m.

**CANON EOS-1DS MARK III, 24-105MM LENS,
ISO 100, 1/180 SECOND AT F/11**

- -

I shot up a ridge right after sunrise in a
wind storm. I don't often place the domi-
nant element of a photo in the exact cen-
ter, but in this case it felt right to give the
feeling of the winds and clouds surround-
ing the two trees.

PAGES 82–83 - Minarets, Snow,
3/1/2011, 6:35 a.m.

**CANON 1D MARK IV, 70-200MM LENS,
ISO 640, 1/1500 SECOND AT F/8**

- -

Taking this photo right at sunrise, I used
a medium telephoto with a high ISO in
order to isolate the Minarets against the
snow-laden backcountry.

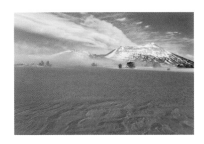

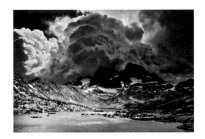

PAGE 85 - Mount San Joaquin, 2/23/2011, 5:20 p.m.
CANON EOS-1DS MARK III, 24-105MM LENS, ISO 100, 1/125 SECOND AT F/11

- -

I arrived to the base of Mount San Joaquin late in the day of my winter trip. I knew I had to start shooting right away to catch the last light on the mountain. A storm was forecast for the following day, and I knew this might be my only chance to get winter photographs with clear weather. As I photographed, clouds started to roll up the valley, engulfing me for a while and then clearing. It gave the feeling of Mother Nature just starting to stir the pot a little before a blizzard.

AFTERWORD - Thunderclouds, Garnet Lake, 8/8/2010, 3:18 p.m.
CANON EOS-1DS MARK III, 16-35MM LENS, ISO 125, 1/125 SECOND AT F/11

- -

It was raining lightly when I took this photo with a 2-stop neutral density filter on the sky. I had to keep drying the filter as the light changed quickly when the sun moved in and out of the clouds. When I made the print, I felt it was important to give the feeling of backlight in the clouds without losing the billowy texture.

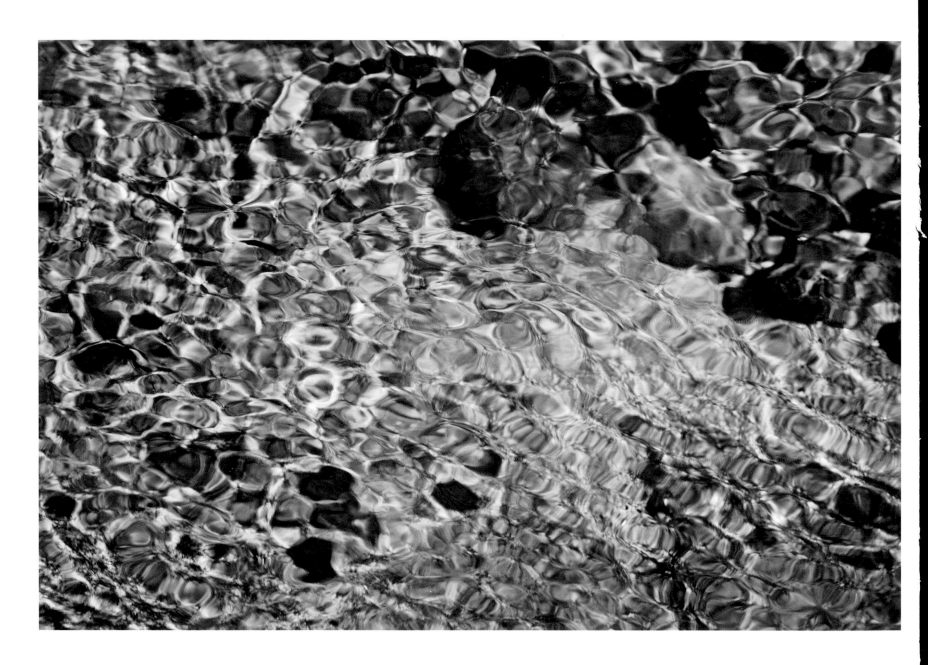

Many shapes take form in a shallow stream near Johnston Lake.

ACKNOWLEDGMENTS

This project started out as a *National Geographic* magazine story. Thanks to Editor Chris Johns for supporting my idea, to Susan Welchman for editing my pictures and always pushing me to do my best work, and to John Baxter for doing an elegant design of the magazine story.

The Wilderness Society stepped up as a partner to make this book possible. A big thank-you to president Jamie Williams for writing the thoughtful foreword, and to Jennifer Stephens for supporting the project from the beginning. Also, thanks to the organization as a whole for doing the good work that it does.

Thanks to Barbara Brownell Grogan for helping secure the sponsorship of the Wilderness Society, and to the team at National Geographic Books: Hilary Black, Gail Spilsbury, Matt Propert, and Elisa Gibson. They have worked together to produce a book of which we can all be proud.

In the field, a big thanks to Tobin Nidever, my hiking companion and guide for three summer backpacking trips in the wilderness. Thanks also to Andrew Soleman at Sierra Mountain Center, who got me into the wilderness on skis in the winter and dug a snow cave so we could survive a fierce storm. Pilot Geoff Pope did a fine job of mountain-flying in his Cessna that enabled me to get an aerial view.

Most of all, thanks to my wife, Jackie, and son, Jalen, for their enduring love.

THE ANSEL ADAMS WILDERNESS
PHOTOGRAPHS BY PETER ESSICK

Published by the National Geographic Society
John M. Fahey, Chairman of the Board and Chief Executive Officer
Declan Moore, Executive Vice President; President,
 Publishing and Travel
Melina Gerosa Bellows, Executive Vice President;
 Publisher and Chief Creative Officer, Books, Kids, and Family

Prepared by the Book Division
Hector Sierra, Senior Vice President and General Manager
Janet Goldstein, Senior Vice President and Editorial Director
Jonathan Halling, Design Director, Books and Children's Publishing
Marianne R. Koszorus, Design Director, Books
Hilary Black, Senior Editor
R. Gary Colbert, Production Director
Jennifer A. Thornton, Director of Managing Editorial
Susan S. Blair, Director of Photography
Meredith C. Wilcox, Director, Administration and Rights Clearance

Staff for This Book
Gail Spilsbury, Project Editor, Text Editor
Elisa Gibson, Art Director
Matt Propert, Photo Editor
Carl Mehler, Director of Maps
Marshall Kiker, Associate Managing Editor
Judith Klein, Production Editor
Mike Horenstein, Production Manager
Galen Young, Rights Clearance Specialist
Katie Olsen, Production Design Assistant

Production Services
Phillip L. Schlosser, Senior Vice President
Chris Brown, Vice President, NG Book Manufacturing
Nicole Elliott, Director of Production
George Bounelis, Senior Production Manager
Rachel Faulise, Manager
Robert L. Barr, Manager

The National Geographic Society is one of the world's largest nonprofit scientific and educational organizations. Founded in 1888 to "increase and diffuse geographic knowledge," the Society works to inspire people to care about the planet. National Geographic reflects the world through its magazines, television programs, films, music and radio, books, DVDs, maps, exhibitions, live events, school publishing programs, interactive media and merchandise. *National Geographic* magazine, the Society's official journal, published in English and 33 local-language editions, is read by more than 60 million people each month. The National Geographic Channel reaches 435 million households in 37 languages in 173 countries. National Geographic Digital Media receives more than 19 million visitors a month. National Geographic has funded more than 10,000 scientific research, conservation and exploration projects and supports an education program promoting geography literacy. For more information, visit www .nationalgeographic.com.

For more information, please call 1-800-NGS LINE (647-5463) or write to the following address:

National Geographic Society
1145 17th Street N.W.
Washington, D.C. 20036-4688 U.S.A.

For information about special discounts for bulk purchases, please contact National Geographic Books Special Sales: ngspecsales@ngs.org

For rights or permissions inquiries, please contact National Geographic Books Subsidiary Rights: ngbookrights@ngs.org

Library of Congress Cataloging-in-Publication Data

Essick, Peter.
 [Photographs. Selections]
 The Ansel Adams Wilderness / photographs by Peter Essick.
 p. cm.
 ISBN 978-1-4262-1329-8 (hardcover : alk. paper)
 1. Sierra Nevada (Calif. and Nev.)--Pictorial works. 2. Ansel Adams Wilderness (Calif.)--Pictorial works. 3. Landscape photography--California. 4. Adams, Ansel, 1902-1984. I. Title.
 F868.S5E7 2014
 979.4'4--dc23
 2013028870

Printed in China

13/RRDS/1

THE WILDERNESS SOCIETY

MISSION

The Wilderness Society's mission is to protect wilderness and inspire Americans to care for our wild places.

The Wilderness Act of 1964 created an extraordinary legacy of enduring protection for America's wildest lands, including the Ansel Adams Wilderness.

Today, wilderness offers more than beauty, solitude, and challenge. It also supports our economy, cleans our air and water, and provides sanctuary for wildlife.

The next 20 years will be critical in securing America's wilderness for future generations. Some of our most precious wildlands are still at risk; once they are developed, drilled, or otherwise altered, they are gone forever. Now is the time to save these lands and create an enduring conservation legacy: your wilderness forever.